The Photographer's MBA

Everything You Need to Know for Your Photography Business

Sal Cincotta

Peachpit Press

The Photographer's MBA: Everything You Need to Know for Your Photography Business
Sal Cincotta

Peachpit Press
www.peachpit.com

To report errors, please send a note to errata@peachpit.com
Peachpit Press is a division of Pearson Education

Editor: Ted Waitt
Production Editor: Rebecca Chapman-Winter
Interior Design: Claudia Smelser
Compositor: Danielle Foster
Indexer: James Minkin
Proofreader: Dominic Cramp
Cover Design: Aren Straiger
Cover Images: Sal Cincotta

ISBN-13: 978-0-321-88892-1
ISBN-10: 0-321-88892-8

9 8 7 6 5 4 3 2 1

Printed and bound in the United States of America

I would like to dedicate this book to my wife Taylor, my mother Terri, and my entire team. This has been one hell of a ride. Without them, none of this would have been possible. Thank you for all your love and support—it never goes unnoticed.

Table of Contents

nine Finding Your Niche

Introduction

Like most photographers, our studio had very humble beginnings. I was a corporate slave working in a cubicle every day, working my tail off for someone else. I loved photography and had been exposed to it at a very early age. My aunt had a darkroom in the basement and my love was born. Now, I'm not going to lie. I had been an amateur for most of my life. Around 2006, a friend and co-worker got me reenergized about photography, and I knew this was what I wanted to be when I grew up.

In 2008, our first year as professionals, our studio grossed $50,000. Hardly a living compared to my salary and benefits in corporate America. We nearly lost everything we had after that year. Looking down the barrel of foreclosure and bankruptcy, I knew something had to change. And it did! I put my business degree to work. Instead of trying to emulate what other photographers were doing in their business, I used my business training to establish a bona fide business model and plan for my newly formed company. And we have never looked back! In 2011, gross sales for our studio crossed the $1 million mark. I share that with you so that you know anything is possible. We grew our business in blue-collar America during the middle of a recession.

When I decided to go pro back in 2008, my biggest frustration was the lack of quality educational material out there. No one would share the business side of things. Everyone wanted to tell you about flash and posing. And

when the topic of business would come up, it was always this cloak-and-dagger conversation. They would share, but not too much. After all, we might steal all their secrets. Well, I needed real substance, not fluff.

Wow, things sure have changed in the last five years! Today, not only is everyone a photographer, but everyone is an educator.

For me, there is a lot of responsibility that comes with being an educator. Unfortunately, I see a lot of people out there for the money, and that is the wrong motivation. Our industry and our profession is in trouble right now. We need help. We need to raise the bar or soon there will no longer be a professional photographer. When I decided to get involved with the educational side of our industry, I knew I had to be willing to share everything I knew. That is my promise to you as a student.

When I was coming up, no one was willing to show what was behind the curtain. Well, here we go. This book is meant to get you on the right track when it comes to the business of photography. It's not tied to any specific genre of photography, nor is it meant to be. Instead, it's a broad overview of the business side of things. If there is something I see photographers struggling with the world over, it's the business side of photography. This is a great launch point for your business. And make no mistake, this is the first in a series of books where we drill down into the various aspects of starting up, maintaining, and growing your business.

In reading this book, the best advice I can offer is to get your highlighter and use this book as a reference for everything you are doing with your business. Read it over and over again until it fully makes sense to you. Most importantly, do something with all this information. Don't sit on it. Look for ways to incorporate it into your business and get your business moving in the right direction.

Much love and success,

Sal Cincotta

For more training and education from Sal, be sure to follow him online:
Web: www.behindtheshutter.com
Twitter: @salcincotta

one

So You Want to Be a Photographer

I N THIS CHAPTER we'll explore the photography industry and the influences that are shaping it today. The industry has gone through immense changes, and unless you truly understand the past, you'll be destined to repeat its mistakes. A career in photography can be extremely exciting, but it's not without its challenges. Once you understand the pros and cons of a career in professional photography, you'll be better equipped to make informed decisions.

While there is little to no barrier to becoming a "professional" if you want to make photography a career versus a hobby, it's best to learn as much as you can before you take the leap. I've been at this since I was 17, and I still learn something new every day. It truly is a journey and not a destination.

A Career as a Professional Photographer

Being a professional photographer can be a rewarding experience. Every day I wake up and realize I'm the luckiest person alive. I get to follow my dreams and passions, all while making a very decent living.

My job is to document life's moments for my clients. I'm in the business of making people happy. My clients love seeing images of themselves during some of the most memorable moments in their lives. Weddings, newborns, high school seniors, and family portraits: all are happy moments in our lives and we get to document them and be the "hero," if you will.

Sure, it's not without its risks or pitfalls, but at the end of the day, would you rather work for someone else doing the same mundane tasks day in and day out, making money for some corporate giant, or would you like to take some risk and enjoy the rewards of your labor? It's not an easy decision to make. As individuals, we're all motivated by different things—some of us are driven by money and the prospect of independence, whereas others want more job security and work-life balance.

Photography offers many opportunities for additional income. In recent years, there has been a huge influx of new photographers into our industry who I refer to as "weekend warriors." Because there's little to no barrier to entry, photography has offered many of us an alternative revenue stream. Be careful, though. Being a photographer comes with great responsibilities. If you're working with people, they have typically entrusted you with their most important memories. Don't take that responsibility lightly.

So let's explore the pros and cons of a career in photography. I'm going to start with the potential negative aspects. I'm not a doom-and-gloomer by any stretch of the imagination, but unfortunately, I meet with a lot of people who

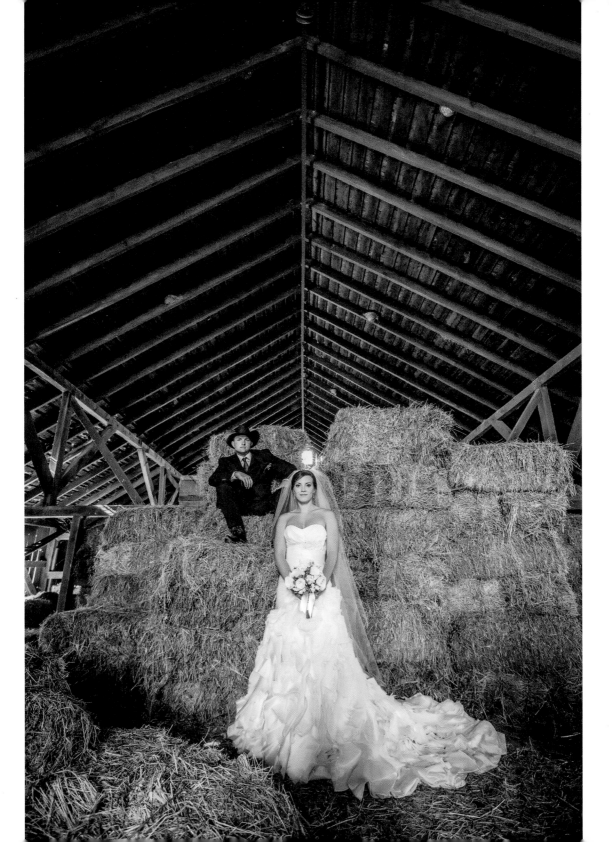

seem to think being a photographer is all glamour, and I'm here to tell you about the realities of being in business for yourself. I find that if you know what you're getting into ahead of time, you're rarely surprised. To be a successful businessperson, you have to operate based on worst-case scenarios. Then, you'll never be surprised if—and when—something goes wrong.

The Cons

It's not an exhaustive list, but these are some of the things I see as potential negative aspects to my job based on my experiences as a wedding and portrait photographer.

The Inherent Risk of Being an Entrepreneur

Make no mistake: if you decide to embark on a career as a professional photographer, you are in fact a businessperson and an entrepreneur by definition. I know a lot of artists who struggle with wrapping their heads around this fact, but though you may be an artist, you are and must be a businessperson first.

As an entrepreneur, you're shouldering all the risks that go along with any business venture. What do you do if someone trips over your bag and hurts themselves? What happens if your gear is lost, stolen, or damaged? These are serious questions you must ask yourself and have a contingency plan for. Without a contingency plan, you run the risk of letting down your clients and might face potential legal action that could impact your business and personal life. So, these are things you have to be thinking about. Throughout this book, we'll discuss various business models and strategies for addressing some of these questions, but we have to start thinking about this now as it shapes our thought process for creating our business plan moving forward.

In addition, you always run the risk of failing. Every successful entrepreneur will tell you they have failed more than they have found success. Failing is and can be a good thing for any business. Don't personalize it, and most importantly, don't let the prospect of failure cripple you from taking the leap to being a professional. Just know and understand that failure is always lurking in the shadows.

For me, I'm a student of the successes and failures of major corporations around the world. I'm a huge believer in learning from the mistakes of others. It always fascinates me to see how a corporation filled with brilliant minds can still make the same stupid mistakes we do as small business owners. From products or services that don't resonate with clients to poor branding, the challenges and solutions are the same for small businesses as they are for large corporations. And at the end of the day, it all comes down to execution.

Center of Operations

Where will you operate from? This should be a burning question in your mind before you embark on this journey. Can you imagine starting a florist business and selling them at your local coffee shop? Sounds ridiculous, doesn't it? However, the new generation of photographer seems to be okay without having a center of operation for their business. You have to be concerned with this; ultimately, clients will make decisions on the validity of your business based on such things.

Put yourself in your client's shoes for a second and ask yourself this: Would you buy a TV from someone selling them in a back alley somewhere? No? Really? Why? I know why—because you would immediately think, "This can't be legit. I mean, he wants $2,000 for a TV I can't turn on, test, anything? What do I do if I have to return this? Will he be here in the alley for me six months from now if something were to go wrong? Probably not." That would be the normal way to think about this, and you'd be correct in being cautious and concerned. (Actually, I'd seriously be worried about you if you were to consider buying that TV. I'm just sayin'.)

You'll find that my barometer for decision making in my business is usually tied to how I would behave as a consumer. If it doesn't pass my personal sniff test, there's no way I'm pushing this out to clients.

Let's come back to my point here. If you'd have caution as a consumer, think about what that bride might be thinking or feeling when you're asking her to invest a couple of thousand dollars into your business—and more significantly, trust you with the most important day of her life.

We'll talk more about a home-based business versus retail space later, but you need to start thinking about this issue now and know it can be a potentially negative and limiting aspect to starting a new business.

Competition

If you're in business, you have competitors. That's a fact! And in this particular industry, everyone is a photographer. With no barrier to entry, you can go to your local big box store, pick up one of those nifty new cameras with its kit lens, and you're in business and ready to go. No need to understand lighting, how to use your camera, digital workflow, business skills, and so forth.

I'm not advocating this approach—I'm merely highlighting the reality of today's landscape. This is the world we live in. My studio is faced with competition from everywhere. Parents who had a child and picked up a camera to document their child's life are now photographers. Studios are popping up all over the place, charging 25 percent of my rates. Worse yet, they are shooting and burning.

SHOOTING AND BURNING

This is a term used to describe photographers who don't try to sell printed products to their clients. Instead, they take pictures, burn them to a CD/DVD, and deliver them to their clients to print for themselves. It is a term and business model that strikes fear into the seasoned studio because it has created a bottom-feeder mentality in our industry. I'd make the argument that this isn't a business model at all and, in fact, is a disservice to the industry. Most importantly, it's a disservice to the client.

In order for us to compete, we don't lower our price or put out an inferior product. I never want my studio to be known as the low-cost provider. Instead, we raise our prices and offer a superior product or service. That's business.

In my opinion, today's consumer is okay with "good enough" when it comes to photography. They're seeing images from almost every kind of device, from iPhones and iPads to point-and-shoot cameras. They're becoming numb to tried-and-true postproduction editing techniques, and it takes more and more to impress a client. That's where other studios and photographers are failing. Instead of innovating, they're settling for "good enough." So consider where you want to position your business and how you plan on getting there. We'll explore your business plan in later chapters.

Work-Life Balance

Being in business means you get to call all the shots, no pun intended. However, it also means you get to call *all* the shots. I can honestly say that I work more hours now than I ever did in corporate America. Yes, I'm here to burst your bubble right now; you can erase those glamorous thoughts of work-life balance, dancing in the park with your spouse with all your free time, and, of course, sleeping in.

Unfortunately, that doesn't exist. Sorry. As a small business owner, you're responsible for every facet of your business. There's no one to cover for you while you are on vacation. Clients are calling expecting customer service, appointments need to be scheduled, accounting books need to be kept, taxes need to be paid, and somewhere in there I'm supposed to take pictures? After all, this is how I make my money. If I don't shoot, I don't get paid.

Of course, there are ways to outsource and find partners and employees to help as you grow, but when you first get started there's a lot of work to do if you're going to run a successful business. And most importantly, this is work you want to be heavily involved in.

When I started out in my business, I was part of everything going on. Sure, I'm a control freak, but when your name is on everything and your reputation is on the line, you better be a bit of a control freak.

Expenses

Startup expenses can be costly, especially in the beginning. I'll never forget my first 60 days in business, where I went through $14,000 like it was play money. And the panic set in. How would I continue to grow? Would the expenses ever end? It was a tough time for me and my family, both personally and financially. I want you to have a realistic appreciation for what your potential expenses could be. They add up quickly.

All too often, photographers are under the impression that all they need is a camera, a lens, and a flash. Trust me when I tell you that you need a lot more than that when you're starting out. Do it right or don't do it at all! That is a mantra you'll hear from me over and over again.

Things to consider right out of the gate:

- Training
- Cameras, lenses, memory cards, flash, battery packs, reflectors, etc.
- Computer (to edit images)
- Hard drives
- Software like Adobe Photoshop, Lightroom, and plug-ins
- Insurance
- Incorporation expenses
- New website
- New logo
- Rent for studio space
- Advertising and marketing expenses to let people know your business exists

And the list goes on and on. Some of these we'll explore in greater detail in other chapters. The main point here is to understand that there can be a lot of hidden costs to starting your own business and to understand that there's a lot more that goes into running your business than merely picking up a new camera.

Legal/Professional Services

If you're serious about starting a business, then you had better get legal. A lot of photographers just grab their camera and continue happily along until something bad happens, and they find themselves—and all their personal assets—exposed to a potential lawsuit.

Incorporating your business is something that you need to do in order to protect and insulate your personal assets from your professional assets. As I mentioned earlier, what happens when you are at an event and someone trips over your bag and seriously hurts themselves? Or you lose a memory card from a wedding event? You'd be naïve to think these things can't happen to you, right? You have to protect your business, and all things considered, it's less expensive to form a legal entity than it is to deal with the fallout if something bad were to happen to your business. The cost of incorporation is about $1000–$1500 in most states. We'll explore the options in Chapter 2, "Let's Talk Business."

In addition, you have to think about your books—you know, those pesky little business tasks like balancing your checkbook, paying taxes, and so forth. When I started out, I thought I could handle all this on my own. I mean, after all, I was a business school graduate and a successful and accomplished corporate leader; surely I could handle tracking my expenses and income. Wow, was I wrong! A year and a half later, I was so far behind it took my accounting team six months to get my books right and all my taxes up to date. The last thing any business wants to spend money on is paying penalties for being late on taxes. This is a serious task and you need professional help ensuring that you're set up correctly, expensing the right things, and paying your taxes on time. Get a referral and meet with an accountant; you'll be surprised by how much they can help you plan in a simple one-hour consultation.

Technology

Ah yes, my favorite: technology. The one thing I learned when I worked at Microsoft is that the only constant today is change. Every day, there's a new social media format, new gadget, lens adapter, light modifier, and Lightroom plug-in, and they're all claiming to be revolutionary. Every day, my competitors are trying to leapfrog my business and steal market share by being more innovative than my studio.

Today, you have to innovate or die. I know that sounds horrible, but it's the truth. I see studios all over the country struggling to survive because they've refused to adapt to the new way of doing business. I feel like we're going through the second major revolution of our industry—at least in my lifetime.

First was the introduction of digital. It changed *everything*! Photographers around the world refused to adopt the new technology and the new workflows that were part of this digital revolution. And today, most, if not all of

them, are extinct. Sure, a handful of photographers still shoot film, but they are few and far between. Just ask the film companies. Oh wait, you can't. They didn't adapt either.

Now, the new revolution is the influx of new shooters into our market. Taking a decent picture has been made so simple by the camera manufacturers that everyone and their mother is now a photographer. The challenge? Competing in a saturated market. In the past, photography was ruled by the geeks. It was a somewhat technical landscape. F-stops, shutter speeds, lighting ratios—what in the world did it all mean? You needed someone who could make sense out of all the technical mumbo-jumbo before they could click the shutter.

Not anymore. Today, slap that bad boy in P for Pro and you're well on your way. The landscape is being ruled by young, trendy, cool hipsters who are more approachable and Internet savvy. And the technically sound photographer is left trying to figure out what a blog is.

I spoke at a conference recently, and I was dumbfounded by the number of people who still hadn't set up a page on Facebook for their business. I got the same question again and again from the established studio: do you really think I need a Facebook page? Um, yeah, like two years ago you needed it. Tomorrow, I'm sure there will be another Facebook-like concept we have to contend with and we must be ready to adapt or we'll quickly become irrelevant.

Client Expectations

Sure, customer service is a keystone to my business—and all our businesses for that matter. However, meeting client expectations can be a challenge for the best businesses in the world. I find that sometimes there are clients that you just can't make happy. No matter what you do, they seem to be looking for what you're doing wrong versus what you did right. I refer to this group as the 2 percenters. Sounds like a gang, doesn't it? Sometimes I wonder if they're all secretly conspiring against the businesses and entrepreneurs of the world, and then I realize they'd probably have a Facebook page for that.

You might be wondering why I see this as a negative thing. Well, for me, I want to take pictures and enjoy the positive and happy side of why I chose to become a photographer. Dealing with client issues isn't something I look forward to every day. And any photographer who tells you they don't have client issues is full of it. We all do. It's how you deal with them that defines your business.

One hundred percent customer satisfaction is nearly impossible to achieve. For example, I once had a bride have a near meltdown because I missed shots at her wedding. When the call came in, I was horrified and immediately started apologizing. I said, "I'm so sorry, what did I miss? I thought I was pretty in tune with the day and everything going on. I was with you for nearly everything." Her response immediately changed my demeanor

and response. "Well, we had artichokes on the table as décor and you didn't take a picture of them." There was a slight pause on my end as I waited for someone to tell me there was a hidden camera in my house and this was a joke. No such luck. I responded, shocked and annoyed. I said, "I'm sorry I missed the artichoke, but you have a million table shots, was there a reason you needed a single shot of the artichoke? Are you planning on printing this?" She answered no. I then asked if she was planning on putting it in her wedding album? She answered no. I said, "Well, I guess I'm a little confused. You're calling me, upset, telling me I missed shots, but you have no plans on printing this or using it in any way, shape, or form. What exactly are we talking about?"

Probably not a good example of good customer service, but the truth is, there are certain clients who are just looking for things to complain about. That's not a glamorous part of being in business for yourself, because you'll ultimately have to be the one dealing with it. Among all the other roles you play, you are the customer service rep.

The Pros

Now I hope I didn't scare you off. My only goal was to open your eyes to some of the negative aspects—challenges, if you will—of being in business for yourself. I love when I talk to new photographers and they are all wide-eyed at the prospect of starting their own business and being a professional, and then they become saddened and disillusioned when things get tough. If you understand the potential challenges and risks before you get started, you'll be well prepared to deal with such issues when they arise.

Let's dig into some of the positive aspects to being a professional photographer. This part will be easy for me—it's what I love about my job.

Creativity

I love being a creative. Every day, I wake up and create. It's like a giant science experiment. I try something out, and if it works, great. If not, I try again. And the process continues. It's the main reason I got hooked on photography. I love being able to create an image the way I envision it. I tell everyone to be

true to themselves as an artist. The worst thing you can do is try to be everything to everyone.

I shoot the way I see the world. This ensures I find the right clients or, in reality, they find me. I think you can look at one of my images and see a part of me in it. And that's what it's all about for me. I'm creating something with a piece of me in it that will last forever.

Are you a creative person? What do you love to shoot? Maybe you don't know yet. Well, get out there and start experimenting. What's the worst thing that could happen? Find your niche. Find what you love and then find a way to apply the business principles I'll teach you to turn it into more than a hobby. Turn it into a career. Turn it into something you can make a living at and support your family with.

Trust me when I tell you that if you do what you love every day, you'll never work a day in your life. I love what I do, and as exhausting as it can be, I wake up excited to go to work every single day. How many people do you know who love to go to work? Exactly. Well, now you know one. Me.

Working for Yourself

This is something that can go either way. You know the old adage: no risk, no reward. However, for me, this is one of the main pros of being a professional photographer. I get to call the shots. It's my business, my vision, my success, and of course, my failure. It's so exhilarating to know that I can create an image, sell it, profit from it, and navigate the future direction for myself. I get to control my own destiny.

This is a totally different mind-set for a lot of people. I run into people all the time who just want to punch a clock 9–5 and have someone tell them what to do. They need that structure to survive. I'm the opposite. My personality is to challenge the status quo...to work outside the box. Oddly enough, it's that differentiation that has allowed my business to thrive in what has been a down economy. My studio stands out from the crowd.

Are you working for a company that has stifled all creativity? How do you define your own success? I think it's a challenge. Being out on your own allows you to control your own destiny. And that, in and of itself, is worth it.

We all need flexibility in our schedules and job tasks. There's never a dull moment in our studio. Every day seems to present itself with new and exciting business challenges. One day I'm shooting for 10 hours and the next I'm working on a marketing plan for our next bridal show. I get to have my hands in a little bit of everything.

I'll never forget when I left my corporate job. My boss thought I was crazy. Hell, I think my entire family thought I was crazy. But I moved forward with one thought in my mind. I'd rather make less money and do what I love than continue to work for someone else doing the same thing every day, being tied to a desk, and meetings, and rush-hour traffic.... I have never looked back. This has been the most amazing journey of my life.

Being in the Business of Happy

Here's something to think about. You are in the business of happy. What do I mean by that? Well, most people come to our studio to create memories and document moments in their lives. When I show them their imagery, they're usually silly happy and so grateful for what we've given them. They truly see it as a gift.

Okay, so let me get this straight, Sal. You get paid for making people happy? Yes. Yes, I do. It's the most amazing feeling in the world to create art for someone that they, along with their families, will enjoy forever. How many people can look in the mirror and say they get to do that?

I take that mind-set into every photo shoot. I want to showcase my clients in the best possible light. I want to deliver to them a snapshot of a moment in time when they remember being happy. That's my gift to them, and that's my job.

I was recently in New York shooting an engagement couple and a high school senior. These were clients who flew in from St Louis. We had a blast with them driving all over the city, talking, sharing goofy stories, and laughing. When it was all said and done, we captured amazing imagery that not only will they be able to look at for the rest of their lives, but they will have a story to tell about each one of those images and how they were created. Best of all, I'll always be a part of that memory. How cool is that?

There's nothing more rewarding than having someone thank you from the bottom of their heart for an experience they'll never forget. That's truly the main fuel that keeps me going no matter how exhausted I may be. I want to be part of something bigger than I am and be part of it in a positive way.

The Money

Whoa. Money? You mean we can make money and be happy at the same time? There is nothing glamorous about being a starving artist. I am a businessman first and an artist second. I'm okay with that distinction. In fact, that's why you're reading this book. You need to understand that without the business, being an artist can be a somewhat fruitless experience. I know there are going to be some purists out there who disagree with my assessment, but did you read the cons of being in this business? If you did, then you'll realize that there's no point in taking all this risk and extra work upon yourself if you aren't trying to make a profit. That just doesn't make any sense.

Now, I won't lie. When I got into this I didn't get into it for the money. I got into it to do what I loved. However, in order to continue doing what I love, I need money. Money for new equipment, training, and the list of things we've already talked about. Not to mention, I want to retire someday. How will you retire if you can barely make ends meet? You need money!

That being said, our business has been more profitable than I could've ever imagined. More profitable than any desk job I'd have had if I'd stayed at my corporate job. None of this would have been possible had I not engaged in basic business concepts for my business. Don't underestimate the importance of being a businessperson first.

The great part about a career in photography is that you can make as much or as little as you want. I mean that with all sincerity. If you told me you wanted to make $250,000 per year, I would tell you that's 100 percent entirely possible. Tell me that's not amazing! Now tell me you can walk into your boss's office at your next review and ask for a $250,000 job. After you pack up your desk you'll be left trying to figure out what's next.

Are you getting this? The sky is the limit for you. There's no end to the possibilities. I'm not saying it will be easy or you'll get to that point working 20 hours a week with weekends and holidays off. Instead, I'm telling you that you are 100 percent in control of your own destiny. And that, my friends, is priceless.

Defining Your Own Success

The one thing I want you to keep in mind throughout this entire book is that you and only you control your destiny. I've mentioned that several times now, but what does that mean? When I'm helping and consulting with new photographers, one of the first questions I ask is, "What does success look like for you?" Sometimes this will catch them off guard. Success doesn't have to be synonymous with money. Success can come in many shapes and sizes. That's ultimately up to you to define. And that's the point.

Ask yourself this: How much do you want to work? How much money are you looking to make per year? And don't forget those pesky expenses. Do you want to travel? When are you looking to retire?

It's by answering questions like these that you'll start to form the foundation of your business plan, which we'll explore in Chapter 3, "The Business Plan." The key here is understanding that you are truly in control of your path. And knowing that this path can change at any time. You might wake up one morning and realize you want to go on a trip to Europe for a month. I say, awesome! You have to pay for that, so maybe you take on a few more events and adjust your plan accordingly. Or maybe you're burned out and want to cut back on events and just chill out by the pool for the summer with your family. Not a problem—just make sure you adjust your plan so that when you decide to pick back up again, you aren't starting from scratch.

The future is bright, and it's yours for the taking! Don't let anyone tell you any differently. Believe in your dreams and believe in yourself.

Now that you have a basic understanding of the risks and rewards of embarking on this new venture, you're in a better place to make an informed decision. The next logical question might be, "How do I get started?"

Getting Started

First, let me tell you how I got started. I was working in corporate and was burned out working for someone else. No matter how hard I worked or how many hours I put in, it never seemed to be enough. And my pay never seemed to match the effort I was putting in. I wanted something different. I was looking for a new challenge.

I got involved in photography at an early age. I was 17 when I shot my first wedding. I assisted someone, and though I enjoyed it, weddings back in the 1980s were, well, pretty freaking lame. I moved over to shooting landscapes, and before I knew it I had a camera with me at all times on every vacation, taking cool pictures of architecture for our home. All the while I was working my corporate job. Never in a million years did I think I'd become a professional photographer.

Back in corporate, a coworker of mine was renting a studio space and wanted me to share it with him. I thought, what the hell. I did it and was immediately hooked again. I couldn't get enough. I was reading every book

out there on lighting and posing. Oddly enough, there weren't many books on the business side of photography.

I was building my portfolio shooting anything I could. I photographed pets, families, couples, children, prenatal. This was a great experience for me; it helped me define my style and gain confidence and experience in my craft. One day, my buddy had a wedding booked and asked me to help. I had no idea what I was doing at this stage of my career. I was like, "Sure, count me in." And it was that day when I found my niche. I literally hijacked the wedding from him. I started directing people, telling them where to go, how to pose, and creating cool scenes in what's now my signature look. I love incorporating people and architecture into an image. It's what our studio has become known for. From that day on, I've never looked back and there has never been a doubt in my mind that I was going to be a professional photographer.

So, how do you get started? Shoot. Shoot. Shoot. Get out there and just start shooting anything and everything you can. You need to build your portfolio and start defining your style. Who are you as an artist? What are you passionate about? What do you want to shoot? If you are shy and timid, you might have trouble working with large groups. If you have an outgoing personality, working with fruit all day isn't going to quite make the grade. I might be tempted to eat it and then go outside and start photographing people. The only way to figure this out is to get out there and work with

someone—or work with everyone. Reach out to friends and family at first. Tell them you're building your portfolio and looking to work with them. Offer them free pictures for their time. It's better than paying a model and it's a win-win for both of you.

Read the damn manual that came with your camera. I can't tell you how nuts it makes me every time I host a workshop and photographers have no clue how to change a setting. Look, I know it's not the most exciting thing in the world to read. But you have to know how to work your tool if you're going to use it correctly. All these shoots you're doing with friends and family—that's your time to experiment and play with different settings on your camera.

As you get more and more comfortable with your camera, consider approaching some local photographers and offering to assist on some photo shoots as a second shooter or even work on their bag. I promise, you'll learn more working on a photographer's bag than you'll ever learn in a book. All the photographers who've worked for me started out on my bag. They have to learn to understand light, how to see a shot before ever taking it, what equipment to use in what situation, and most importantly, understand my thought process and how to deal with the unexpected. You'll gain priceless knowledge.

I think it's at this point you're ready to consider going out on your own and moving toward building a business plan. You'll be armed with some experience and an understanding of what type of photography you'd like to offer. And most essential of all, you'll have a portfolio of work to show prospective clients.

Final Thoughts

A career in photography can be both rewarding and challenging. Just understand there's more to it than buying a new camera. A true professional is armed with knowledge about the potential pitfalls their business will face and the knowledge to correctly navigate the competitive landscape that lies ahead.

Although there's seemingly no barrier to entry, you'd be foolish to jump in without asking yourself basic questions and ensuring you know where you're heading on this new journey. Remember, do it right or don't do it at all. Take the time up front to ensure that you're making the right choices— doing so will save you pain and money in the future.

Next Steps ▶▶▶

▶ Make sure you have a thorough grasp of the pros and cons of being a professional photographer.

▶ Connect with friends and family and start shooting as much as you can. On every shoot think about learning and building your portfolio. Shoot without fear. Don't be afraid to experiment.

▶ Find your niche. What do you want to shoot? Where is your passion?

▶ Find photographers whose images inspire you. Use them for inspiration in your shooting.

▶ Find online resources for learning. Learn about lighting techniques, posing techniques, and the various aspects of producing a great image.

▶ Once you're ready, try getting an internship or part-time work with a photographer who would be open to training and mentoring you.

Let's Talk Business

N THIS CHAPTER we'll discuss the various types of business entities and how they'll impact you, both personally and professionally. Make no mistake: as we discussed in the previous chapter, it takes more to be a professional photographer than just buying a camera.

What business type is best for you? A sole proprietorship, a partnership, an S-Corp, a C-Corp, or maybe an LLC? We'll dive into each of the various types and break them down into an easy-to-understand decision tree that's right for you.

These are things you have to consider sooner rather than later. These are decisions that will impact your income, taxes, business, and ultimately your liability. Don't underestimate the importance of getting your business entity set up and running correctly right out of the gate.

It is without a doubt one of the most important decisions you'll make for your business.

Make It Real

Everyone gets excited when they get that shiny new camera and they start taking pictures for the first time. Trust me, I know how it starts. First, maybe you are taking pictures of your family and friends. Then someone in your life makes the statement, "Hey, you should charge money" or better yet, "I need a photographer for my wedding. Can you do it?" And suddenly, your hobby has become a job.

But are you ready? What was once a fun hobby has now become a mission-critical task with responsibilities tied to it. Don't get me wrong. I'm not trying to scare you away from being a professional, but if you're going to do it, you have to adjust your way of thinking. You have to start thinking like a business. Now, where money is involved, there are risks and exposure for you both on a personal and a professional level. How are you going to mitigate that risk? Now is the time. Make it real and protect your business, your family, and your future.

Let's explore the various types of businesses and how they are applicable to your potential new business. It's very important that you make the right business type selection. Though it can be changed, that change is not without significant cost.

Types of Business Entities

There is a never-ending list of business types to consider. This can be truly overwhelming. Hopefully, I can shed some light here and break it down in a way that's easy to understand.

Most people don't realize that under most circumstances their business entity is managed and incorporated at the state level. Though the federal government does have some classifications, in most cases, these are banks and other financial institutions that are incorporated at the national level. For our purposes, we'll focus on the state level and the various business types offered at that level.

Keep in mind, this is meant as a general guide for you. Use it to help inform your decision process and to help you understand your options. (And

be sure to check out your options online with great resources like entre-preneur.com and business.usa.gov.) No matter what you decide, I highly encourage you to consult with your accountant to better understand how your setup will impact your business and personal finances. Also, each state has its own rules for creating each of these entities, so be sure to check with your state for more information.

Here are the business designations we'll explore:

▸ Sole Proprietorship

▸ DBA

▸ Partnerships: General Partnership, Limited Partnership, LLC

▸ Corporations: S Corporation and C Corporation

Sole Proprietorship

Definition

The sole proprietorship is the simplest business form under which you can operate a business. The sole proprietorship isn't a legal entity. It simply re-fers to a person who owns the business and is personally responsible for its debts. A sole proprietorship can operate under the name of its owner or it can do business under a fictitious name, such as Salvatore Cincotta Photog-raphy (see the DBA section a bit later). The fictitious name is a trade name; it doesn't create a legal entity separate from the sole proprietor owner.

The sole proprietorship is a popular business form due to its simplicity, ease of setup, and nominal cost. A sole proprietor need only register his or her name and secure local licenses, and the sole proprietor is ready for business. A distinct disadvantage, however, is that the owner of a sole proprietorship remains personally liable for all the business's debts. So, if a sole proprietor business runs into financial trouble, creditors can bring lawsuits against the business owner. If such suits are successful, the owner will have to pay the business debts with his or her own money.

The owner of a sole proprietorship typically signs contracts in his or her own name, because the sole proprietorship has no separate identity un-der the law. The sole proprietor owner will typically have customers write

checks in the owner's name, even if the business uses a fictitious name. Sole proprietor owners can, and often do, commingle personal and business property and funds, something that partnerships, LLCs, and corporations cannot do. Sole proprietorships often have their bank accounts in the name of the owner. Sole proprietors need not observe formalities such as voting and meetings associated with the more complex business forms. Sole proprietorships can bring lawsuits (and can be sued) using the name of the sole proprietor owner. Many businesses begin as sole proprietorships and graduate to more complex business forms as the business develops.

Tax Implications

Because a sole proprietorship is indistinguishable from its owner, sole proprietorship taxation is quite simple. The income earned by a sole proprietorship is income earned by its owner. A sole proprietor reports the sole proprietorship income and/or losses and expenses by filling out and filing a Schedule C, along with the standard Form 1040. The "bottom-line amount" from Schedule C is transferred to your personal tax return. This aspect is attractive because business losses you suffer may offset income earned from other sources.

Again, consult with your accountant to fully understand the tax implications of this form of business.

Legal Implications

Sole proprietors are personally liable for all debts of a sole proprietorship business. This potential liability can and should be alarming to you. Assume that a sole proprietor borrows money to operate but the business loses its major customer, goes out of business, and is unable to repay the loan. The sole proprietor is liable for the amount of the loan, which can potentially consume all personal assets.

Imagine an even worse scenario: the sole proprietor (or even one of your employees) is involved in a business-related accident in which someone is injured or killed. The resulting negligence case can be brought against the sole proprietor owner and against their personal assets, such as their bank account, retirement accounts, and even their home.

To make it even more real, think about an event you might be working and the real possibility of someone injuring themselves by doing something as simple as tripping over your lightstand. You're now personally responsible and liable.

Pros

▸ Owners can establish a sole proprietorship instantly, easily, and inexpensively.

▸ Sole proprietorships carry little, if any, ongoing formalities.

▸ A sole proprietor need not pay unemployment tax on himself or herself.

▸ Owners may freely mix business or personal assets.

▸ Owners maintain control of all decision making.

▸ No special tax forms are required for your business.

Cons

▸ Owners are subject to unlimited personal liability for the debts, losses, and liabilities of the business.

▸ Owners cannot raise capital by selling an interest in the business.

- Sole proprietorships rarely survive the death or incapacity of their owners and so do not retain value.

- Sole proprietorships provide less of a professional appearance than other types of businesses.

- You could have difficulty in raising financing or capital for ongoing business operations or growth. This is due to the fact that the business has little or no assets.

My Thoughts

While on the surface this may appear to be the easiest and simplest form of business entity there is to set up, it's not without significant risk.

In most cases, you can be set up and running in no time at all. However, the liability concerns here are almost impossible to ignore. For us, when we started our business, I was concerned about something I felt was a reality. Is it possible for someone to trip over my gear bag at an event? I think that's a realistic possibility. And as such, I don't want to risk my personal assets and that of my family's future. My home, my retirement, future earnings, etc.—all this would be put at risk.

For us, the ease of setup and tax reporting wasn't enough to offset the huge personal risk we'd have to absorb. And it's because of this that we didn't opt for a sole proprietorship for our business.

Doing Business As (DBA)

Definition

This is the operating name of your company, which differs from the legal name. Certain states require a filing of the fictitious name to protect consumers conducting business with this entity. If you're starting a sole proprietorship or a partnership, you have the option of choosing a business name or DBA ("doing business as") for your business. If you want to operate your business under a name other than your own (for instance, Sal Cincotta doing business as "Salvatore Cincotta Photography"), you may be required by the county, city, or state to register your fictitious name. (Note: No fictitious business name may include the words "corporation," "Inc.," "incorporation," or "Corp." unless it's a corporation registered with the Secretary of State.)

The processes of filing for a fictitious name vary among states. In many states, all you have to do is go to the county offices and pay a registration fee to the county clerk. In other states, you also have to place a fictitious name ad in a local newspaper for a certain amount of time. The cost of filing a fictitious name notice varies so be sure to check with your local papers—generally, this is inexpensive. Your local bank may also require a fictitious name certificate to open a business account for you. In most states, corporations don't have to file fictitious business names unless the corporations do business under names other than their own. Incorporation documents have the same effect for corporate businesses as fictitious name filings do for sole proprietorships and partnerships.

Tax Implications

The tax implications are the same as the business legal type. So, if you're a sole proprietor you'd have the same tax implications. The same would be true if you were a corporation DBA "fictitious name."

My Thoughts

This type can be best if you're creating multiple studios or lines of business. For example, let's say you are a family or senior portrait photographer who also wants to explore boudoir photography. This would be a great way to keep the same legal formation of your company but create a distinctive

name for your new venture that is separate from your main business focused on families. If my main business name is Salvatore Cincotta Photography, I could create legal paperwork with Salvatore Cincotta Photography DBA (doing business as) Upscale Boudoir. Doing so allows me to open a checking account and other items under that new business's pseudo name.

Partnerships

Definition

Partnerships come in two varieties: general partnerships and limited partnerships. In a general partnership, the partners manage the company and assume responsibility for the partnership's debts and other obligations. A limited partnership has both general and limited partners. The general partners own and operate the business and assume liability for the partnership, whereas the limited partners serve as investors only; they have no control over the company and aren't subject to the same liabilities as the general partners. Unless you expect to have many passive investors, limited partnerships are generally not the best choice for a new business because of all the required filings and administrative complexities. If you have two or more partners who want to be actively involved, a general partnership would be much easier to form.

Tax Implications

At tax time, the partnership must file a tax return that reports its income and losses to the IRS. In addition, each partner reports his or her share of income and losses on Schedule K-1 of Form 1065.

Legal Implications

Personal liability is a major concern if you use a general partnership to structure your business. Like sole proprietors, general partners are personally liable for the partnership's obligations and debts. Each general partner can act on behalf of the partnership, take out loans, and make decisions that will affect and could be binding on all the partners. Keep in mind that partnerships are also more expensive to establish than sole proprietorships because they require more legal and accounting services.

Pros

▸ Partners share the cost of startup.

▸ Partners share the responsibilities.

▸ Partners share the risk.

▸ One of the major advantages of a partnership is the tax structure. A partnership does not pay tax on its income but "passes through" any profits or losses to the individual partners.

Cons

▸ Partners share the profits.

▸ The lack of total control of the business or assets can lead to internal disputes about the direction of the company and ultimately end in the dissolution of the business.

▸ Like sole proprietors, general partners are personally liable for the partnership's obligations and debts.

▸ Partnerships are more expensive to establish.

▸ A risk of dissolution of the company exists with the loss or removal of a partner.

My Thoughts

I like to control my own destiny, so the thought of a partnership isn't one that's appealing to me, especially when it comes to a photography business. These types of businesses are typically tied to a single person's vision, and I wouldn't want someone else to be able to control that vision or share in the success of my vision unless they were bringing something very powerful to the table that I couldn't live without.

If you decide on this route for your new venture, be sure you draft a partnership agreement that details how business decisions are made, how disputes are resolved, and how you'd handle a buyout.

Limited Liability Companies (LLC)

Definition

A modern corporation's heavy administrative burden is a remnant of the more traditional and formal legal system under which corporate law was cultivated. The LLC changed all that.

Limited liability companies (LLCs) have been around since 1977, but their popularity among small-business owners is a relatively recent phenomenon. The LLC offers the liability protection benefits of the corporation without the corporation's burdensome formalities. This simplicity has made the LLC an instantly popular business form for smaller companies.

LLCs are the favorite choice for small businesses with between one and three working owners who don't plan to grow the business significantly and don't expect to raise significant amounts of cash. But as the number of owners grows, the corporation often becomes a more attractive choice as a business form.

An LLC is a hybrid entity, bringing together some of the best features of partnerships and corporations. LLCs were created to provide business owners with the liability protection that corporations enjoy without the double taxation. Earnings and losses pass through to the owners and are included on their personal tax returns.

This sounds similar to an S corporation—discussed in a moment—except an LLC offers small-business owners even more attractions than an S corporation. For example, there's no limitation on the number of shareholders an LLC can have, unlike an S corporation, which has a limit of 75. In addition, any member or owner of the LLC is allowed a full participatory role in the business's operation; in a limited partnership, on the other hand, partners aren't permitted any say in the operation.

Unlike corporations (and like partnerships), LLCs don't have perpetual life. Some state statutes stipulate that the company must dissolve after 30 or 40 years. Technically, the company dissolves when a member dies, quits, or retires.

Pros

▸ The members enjoy limited liability, which means they're personally protected from any liability of the LLC and successful judgments, as well as from the LLC itself.

▸ The members' share of the bottom-line profit of an LLC isn't considered earned income, and therefore isn't subject to self-employment tax.

▸ As a member, you can contribute capital or other assets to the LLC, or loan the LLC money to put dollars or value into the business. You can take dollars out by taking a repayment of your loan (plus interest), a distribution of profit, or a guaranteed payment.

Cons

▸ Each member's pro-rata share of profits represents taxable income—whether or not a member's share of profits is distributed to him or her.

▸ The managing member's share of the bottom-line profit of the LLC is considered earned income, and therefore is subject to self-employment tax.

▸ For companies that wish to pursue venture capital, accumulate a large number of shareholders, and/or eventually pursue an initial public offering, the LLC isn't an appropriate alternative to a corporation.

▸ Members of an LLC aren't allowed to pay themselves wages.

My Thoughts

Potentially, I like the LLC as an option. The only concern I'd have is the life span of the company if one of the members quits, retires, or dies. And the fact that you wouldn't be able to pay yourself wages does have significant tax implications. For the weekend warrior, I don't think this is a good fit. It's too complicated a structure to set up and maintain, and it hinders your ability to grow and profit from your company. There are better options out there, which we'll discuss next.

Corporations

Definition

A corporation is created under the laws of the state as a separate legal entity that has privileges and liabilities that are separate from those of its members. There are many different types and forms of corporations; for our purposes we'll explore one of the most popular among small business owners, an S corporation.

An important feature of a corporation is limited liability. If a corporation fails, shareholders may lose their investments and employees may lose their jobs, but neither will be liable for debts to the corporation's creditors.

Despite not being natural persons, corporations are recognized by the law to have rights and responsibilities like natural persons ("people"). Corporations can exercise human rights against real individuals and the state, and they can themselves be responsible for human rights violations. Corporations are conceptually immortal, but they can "die" when they're dissolved either by statutory operation, order of court, or voluntary action on the part of shareholders.

The S corporation is often more attractive to small business owners than a standard (or C) corporation. That's because an S corporation has some appealing tax benefits and still provides business owners with the liability protection of a corporation. With an S corporation, income and losses are passed through to shareholders and included on their individual tax returns. As a result, there's just one level of federal tax to pay versus a C corporation, where the business is taxed along with the distributions to its shareholders.

A corporation must meet certain conditions to be eligible for a subchapter S election. First, the corporation must have no more than 75 shareholders. In calculating the 75-shareholder limit, a husband and wife count as one shareholder. Also, only the following entities may be shareholders: individuals, estates, certain trusts, certain partnerships, tax-exempt charitable organizations, and other S corporations (but only if the other S corporation is the sole shareholder).

Pros

▸ Income from the profits or losses of the company are passed to the shareholders, who in turn allocate those figures on their personal income tax returns.

▸ The corporate entity generally shields shareholders and directors from the debts and obligations of the company.

▸ S corporations can be used to own property such as real estate or other assets due to S corporation tax advantages and for protection from liability.

▸ If an owner dies or sells his interest, the corporation continues to exist and do business unless formally dissolved. This is one of the S corporation benefits over sole proprietorships and most partnerships, which dissolve upon the death or sale of an owner, limiting the salability of these types of businesses.

▸ Tax advantages can be realized through distributing money from the S corporation to shareholders-employees as profits rather than as salary. It stems from the fact that profits aren't subject to the over 15 percent in Social Security and Medicare taxes that salaries are.

Cons

▸ S corporations are subject to many of the same requirements corporations must follow, and that means higher legal and tax service costs. They also must file articles of incorporation, hold directors and shareholders meetings, keep corporate minutes, and allow shareholders to vote on major corporate decisions.

- The legal and accounting costs of setting up an S corporation are also similar to those for a standard corporation. And S corporations can only issue common stock, which can hamper capital-raising efforts.

- Each shareholder must be a U.S. citizen or resident.

- S corporations can never have more than 75 shareholders.

- Profits or losses must be distributed in direct proportion to ownership interest.

My Thoughts

This is the best of both worlds. You get to limit your personal liability via the corporate mechanism and still enjoy the profit and losses on your personal tax returns, allowing for a lower tax rate. For these reasons, we chose this type of entity for Salvatore Cincotta Photography. Not to mention, if we ever wanted to sell our business, we can do that without dissolving the business. This is key, and it matched with our overall business plan for the business.

Just to give you perspective, when we first opened the doors of our studio, we were set up as a sole proprietor, but we quickly realized that our personal assets were highly exposed. Within the first six months we made the investment to become an S-Corp. Trust me when I tell you, it only takes one mistake to run the risk of losing everything. For the $600–$1,000 it takes to become an S-Corp, there's no reason not to.

In the beginning it was just Taylor and me as the principals and employees. Today, we have four employees within the Salvatore Cincotta Photography company: Taylor and myself along with two full-time employees. We anticipate that number will grow over the next 12 months; being an S-Corp, we are well poised for growth.

Whatever you decide, be sure to talk to a tax and legal professional. They'll help you balance your vision with the long-term financial and legal implications. In the next chapter, we'll explore your overall business plan, and that might influence your decision on which business type is right for you.

three

The Business Plan

NOW THAT YOU know you want to be in business, it's time to put an actual plan together so that you can start implementing the various tasks that lie ahead. Starting a business without a plan is like walking into a dark room and aimlessly looking for a light switch. You might find it in 10 seconds or you might never find it. Your business plan is your blueprint, and it will ensure you're on the right path to success.

It Doesn't Have to Be Painful

Don't overcomplicate things. It doesn't have to be hard to put this together. Business plans come in all shapes and sizes. They can be as simple as bullets on a whiteboard or as complex as a Fortune 500 company diving into a new venture. Whatever you decide, it's more important that you document your goals and vision than wander around aimlessly.

And for the record, we've done both. In some years, we're very detailed in our plan; in other years, we use a whiteboard to track objectives.

Now you might be thinking to yourselves, "Wait, Sal, are you saying I have to do this every year?" The short answer is a resounding yes!

Although you don't want to reinvent your business every year, I think there's a certain part of your plan that should be a living document. This ensures your company remains nimble and relevant. I've watched companies in all industries die a painful death because they refused to change direction—a direction, I will highlight, that was being driven by a faulty and outdated business plan.

You don't have to look far to see the graveyard of companies in our own industry that refused to change direction. Kodak is one of the first companies that comes to mind. They blatantly—and I would argue irresponsibly—ignored the digital revolution that was coming and kept executing on an obsolete business plan. By the time they started to react, it was too late. Smaller and nimbler companies stole massive amounts of market share from them or established themselves as leaders in their respective segments. This forced the one-time industry leader to play catch-up for the first time in their history. And the rest is, well, history.

The question is, what can you do to ensure this doesn't happen to you or your business? There are a lot of lessons to be learned from the world of corporate America. Don't ever underestimate these scenarios or think that it can't happen to you. It has happened to small businesses all over the world and it can happen to you!

For our business, we want to make sure we're always leaders in our industry, both on the consumer side and on the educational side. In order for that to happen, we have to consistently reevaluate our business plan and ensure we're heading down the right path. We treat our business plan as a living document that can and should evolve over time.

Let's start with some basic definitions to establish key terms.

Key Terms and Definitions

Business Plan

A *business plan* is a formal set of business goals, data to support how they're attainable, and the plan for reaching those goals. It can contain information about the team working toward achieving those goals. The plan should also identify the target demographic, branding, and needed financing.

The business plan can be targeted toward an internal audience or an external audience. If you're looking to raise capital to jump-start your business, you'll need to put together a plan targeting an external audience. This plan should highlight the team and their qualifications that will make executing this plan possible. In addition, you'll have to identify your target market, how you'll market to them, change perceptions, create an IT plan, and so on. Remember, these are people investing in your business, so they're going to want to see all the information needed to make a decision.

For an internal audience—that's you, by the way—you need a similar plan, but you won't have to establish your qualifications since you shouldn't be trying to impress yourself. The goal here is to ensure you understand your product/service and your plan for achieving your goals and objectives.

Mission Statement

A *mission statement* is a statement of the fundamental purpose of the company or organization. The mission statement should guide the actions of the organization, spell out its overall goal, provide a path, and guide decision making. It provides the structure for the company to guide and formulate its strategies moving forward.

Vision Statement

The *vision statement* outlines what the organization wants to be. It can be emotive in nature and based on ideals. It's a long-term view and serves as a source of inspiration for the organization.

Critical Success Factors

These are the factors or elements that are vital to ensure that your strategy is successful. This is what's important in order for you to execute your business plan.

Strategic Planning

Strategic planning is an organization's process of defining its strategy, direction, and decision-making process. To determine the direction of the organization, you must understand its current position and the possible opportunities available to the business. Typically, strategic planning addresses these questions. What do we do? Who do we do it for? And what is our competitive advantage?

Putting It into Practice

Now that you have an overview of some high-level definitions, let's put some of these concepts into practice with some real-world exercises and examples. Our goal here is to show you how to put some of these concepts into motion with your own business. So, get out a pen and pad and start working this into your own business. Do not take these exercises lightly. Even if you have been in business for the last 20 years, you can always retune and reinvent your business. This should become part of the culture of your organization.

Your Mission Statement

Your mission statement should highlight the fundamental purpose of your business. So, here's what I want you to do at this point. I want you to think about the following: What type of photography do you want to get into? And your answer cannot be "all of it." I want and need you to think about what specific type of photography you're looking to build your business around. When you look out over the next 5–10 years, what do you see yourself doing?

This is a very important step. When I started out, I was doing a little bit of everything and I was miserable! I quickly realized that there was no way I could

be everything to everyone. I wanted to do what made me happy, and senior portraits and weddings are my passion. If you look at my website, you'll see nothing but seniors and weddings. Do we shoot other types of photography? Of course we do. However, it's on a very limited basis. My business is built on these two types of photography and everything we do has to be tied to that.

Next, I want you to think about why your business will exist. I probably just blew your mind with this. I can hear you now: "What do you mean 'why do we exist?' We exist to make money." If that's your initial answer or initial thought, you might want to step away from this book for a few moments.

Sure, on a basic level, all businesses have to turn a profit of some sort. The business has to be able to pay its bills, grow, advertise, and so forth. However, I would make the argument that when it comes to your mission statement, there needs to be a bigger motivator than just money. Without it, you will fail! And you will fail because you and your business are, at the core, being driven by the wrong motivator—money.

For us, on the educational side, my business behindtheshutter.com exists to raise the bar of professional photography around the world and help photographers reach their true potential. Notice I didn't say a word about money. If you run the other aspects of your business correctly, money will ultimately find you and be the reward of a well-executed business plan.

Let's look at Coca-Cola, one of the world's most recognizable brands, for some inspiration here. Their mission: to refresh the world, to inspire moments of happiness, to create value, and to make a difference.

See anything in there about money? Their mission statement serves as their foundation for everything the company does.

How about this for a potential mission statement? "At XYZ Studio, our mission is to offer our clients the best wedding and senior portrait photography available, to create artwork and lasting memories for our clients that will be cherished for generations, and to leave a positive and lasting impression with the families we interact with."

This is something I quickly put together. You should spend time thinking about your ultimate goals. A mission statement will dictate the strategy of your company and serve as a blueprint for you as you grow in the future.

Your Vision Statement

While your mission statement dictates the purpose of your company, your vision statement dictates the actions needed to become the company you want to be. Think of it as a framework.

Don't get confused by this concept. You might initially look at this and think, "What's the difference between a mission and vision? They sound the same."

Think of the vision as a high-level set of tenets that must be adhered to in order to accomplish your mission. You don't want to get too granular here (for example, "must send out direct mail during the month of June"). You want your vision to focus on a very high level so that as your business evolves and the landscape changes, you can still adhere to your vision yet change your tactics to achieve that vision. This allows your company to be nimble when dealing with the never-ending changes in our industry.

Let's go back to Coca-Cola for some real-world examples. Their vision statement reads as follows:

Our vision serves as the framework for our roadmap and guides every aspect of our business by describing what we need to accomplish in order to continue achieving sustainable, quality growth.

People: Be a great place to work where people are inspired to be the best they can be.

Portfolio: Bring to the world a portfolio of quality beverage brands that anticipate and satisfy people's desires and needs.

Partners: Nurture a winning network of customers and suppliers; together we create mutual, enduring value.

Planet: Be a responsible citizen that makes a difference by helping build and support sustainable communities.

Profit: Maximize long-term return to shareowners while being mindful of our overall responsibilities.

Productivity: Be a highly effective, lean, and fast-moving organization.

One thing that should immediately jump out at you is the fact that their bullets are very generic and high level. They're trying to create a framework to guide the organization in achieving its goals and objectives. And with Coca-Cola's history, I would say they're doing something right.

So, let's try to apply this to our world:

▸ **People.** Be a great place to work where people are inspired to reach their creative potential.

▸ **Partners.** Nurture a network of professional relationships, creating enduring value for our clients.

▸ **Productivity.** Be a highly effective, lean, and fast-moving team ready to adapt to a quickly changing marketplace.

▸ **Customers.** Value the relationship of our customers, making their experience a positive and memorable one.

Again, this is something I spent a little time thinking about, coming up with some real tenets that can help drive the business in the right direction. In addition, think about this: as your business grows and you add new staff, additional shooters, and so forth, how will you communicate with them to ensure they share the same vision as you do for your company? This is how. Document it and make it real for everyone to see, including your clients.

I highly recommend placing your vision and mission statements on your website for the world to see. Today, I see photographers posting what they had for breakfast on their blog—which no one cares about, by the way—but for some reason we're shy about posting the core beliefs of our company? Think about it. This is what clients care about when they're selecting a company to document one of the most cherished moments in their lives.

The Business Plan

Okay, so you have your vision and mission statements. Now you have to start drilling into the business plan. Remember, this doesn't have to be a 30-page document. It can be as simple or as complex as you like. And since you're more than likely not looking for venture capital for your business, we're going to focus on an internal document versus an external one (for a bank, for example). This becomes your living document that should drive your one-year, two-year, and five-year goals. And I strongly emphasize that this is a "living document" because my five-year plan today looks nothing like it did when I first started my business. And that's to be expected. It's a sign that our business is dynamic and responsive to changing market conditions.

First let's identify the key elements of the business plan you'll be putting together:

- ▸ Executive summary
- ▸ Market analysis
- ▸ Company description
- ▸ Organization and management
- ▸ Marketing and sales strategies
- ▸ Service or Product Line
- ▸ Financial Projections

This is a great starting point, and thought some of these might seem complicated or overkill for your business, I promise you once you get through this, you'll see how priceless this document will be for your business, especially if you're just starting out. I do a lot of consulting for businesses, and the number of businesses that have not taken this step forever dumbfounds me. It's vital to the success of your venture.

Executive Summary

The executive summary is widely considered the most important part of your business plan. Think of it as the who, what, when, where, and why of your business. It's the one place you can look to define most aspects of your business. The executive summary should highlight the overall strengths of your plan, and it's usually the last piece that you write. However, it's the first in your final document. Here's what's included.

If you're an established business, you should include the following information in your executive summary:

▸ The mission statement. This should already be completed.

▸ Company information. This is a short statement that covers when the business was formed, the names of the founders and their roles, number of employees, location information, and so forth.

▸ Growth highlights. This includes information about the company, when it was founded, year-over-year growth using graphs, your market share, and so on.

▸ Your products or services. Describe the products or services you provide and who you're targeting with them.

▸ Summarize future plans. Where are you going with the business? What are the ultimate goals over the next 12 months?

If you are a new business, you might not have some of the financial information as of yet. That's okay. Use forecasted numbers based on market data. It's a best guess and should be based on a somewhat realistic assessment of your market, but it serves as a checkpoint for your business moving forward.

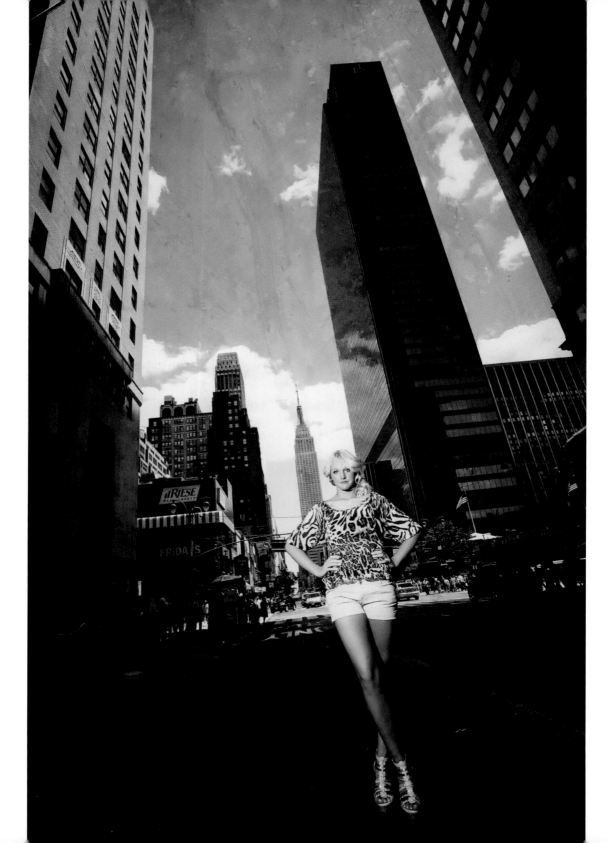

Market Analysis

Your market analysis should contain information about the industry and market research. For example, if you're going to be a wedding photographer in New York City, what does that market look like? How many weddings per year are there in your defined market? What is the average spend on wedding photography in your market?

What's included in the market analysis:

▶ **Industry description and outlook.** Describe your industry, including the current size and any historical and projected growth numbers.

▶ **Information about your target market.** Here you'll have to do some thinking about the target you're going after. If you're talking weddings, every couple getting married wouldn't be your defined target. That's completely unmanageable. Who is your target? That can be defined by demographic data like religion, income level, geography, and similar factors. If you're talking about families, you face the same challenges. You can't possibly go after every single family out there. You have to narrow this down to a manageable number. This is an exercise for you to consider on your own.

▶ **Competitive analysis.** This is where you identify your competition in the market segment you're going after. What market share do they have? What are their strengths and weaknesses? What barriers to entry are there to getting started in this segment?

Regarding the target market, for us, we focus on mid- to high-end weddings—people willing to spend $5,000–12,000 on wedding photography. If we were to drop that number to $3,000, we'd place our studio within an entirely different competitive range and within a completely different client base.

Once you narrow this down, what is the size of your target market? What are some of the behavior characteristics of that market—average spend, for example? What are the demographics of that target? Income level, geography?

Some of this data is easier to find than other data. I recommend working with local event planners and venues in addition to doing your research online.

Company Description

The company description provides a high-level overview of your business and the various elements of your business. This is where you define the goals of your business and the unique value proposition you offer the market segment you're targeting. Here's how you should tackle the company description:

▸ Describe the nature of your business and the needs you are trying to satisfy.

▸ Explain how your products or services meet those needs.

▸ List the specific consumers and target market that your business will serve.

▸ Explain and list your competitive advantages.

Organization and Management

Don't let this part of the business plan overwhelm you. If you are like most small companies, you are the owner, manager, photographer.... I get it; we all wear different hats. And there is nothing wrong with that. However, if you're working with your spouse or friend, this becomes a great place to clearly highlight roles and responsibilities so you don't kill each other during stressful periods.

In this section, you need to include the organizational structure and details about the ownership of the company—basically, who does what for the business. Here's what's included:

▸ **Organizational structure.** In its simplest form, this is where you create an organizational chart for your business highlighting reporting lines and titles.

▸ **Ownership information.** Here's where you describe the legal structure of your business along with the ownership information. Include names of the owners, percentage ownership, involvement in the company (silent partner or managing partner), etc.

▸ **Management profile.** This might seem like a pointless exercise, but it truly is a great way to look at your business and key roles in a way that will quickly show you holes in your structure—holes that could ultimately lead to the failure of your business. As a photographer, it's an all too often perceived notion that all you need is a camera and you're ready to go. Sounds good. So now that you have the image, who's in charge of marketing? Post-production? Sales? This is where most businesses fail. They don't have the required people or partners to fill the gaps in their management team.

It's okay to not have all these skills. Very few people do. So, you either hire these people or bring in partners to assist you. But you have to make yourself aware of the problem before you can fix it.

Marketing and Sales Strategies

In its simplest form, marketing is defined as the activities involved in the transfer of goods from the producer to the consumer. This includes advertising and selling. It's all part of your marketing strategy. A lot of people think of advertising as a separate discipline; however, it's part of your marketing strategy. And it's typically the most expensive part of your marketing strategy.

There's no right or wrong way to approach your marketing strategy. It should, however, be part of a living process and document that's continuously evaluated and nurtured based on market demands and changes. What worked in the 1990s might not work today. Our philosophy is simple: we will typically try anything once, but if it doesn't work, we move on.

Your overall marketing strategy should include:

▸ **Market penetration strategy.** How are you going to get into the market? There are a lot of photographers out there. What makes you different? Are there relationships you need to initiate to be successful? Who and how will you foster these? For weddings, you might need to partner with some of the wedding planners or the wedding receptions halls. How will you do this? If you are a senior photographer, you might need to get into the schools on the preferred vendor list. How will you do this? Who do you need to contact and work with at the various schools?

▸ **Growth strategy.** What is your plan to grow the business? For example, if you shot 5 weddings and 10 seniors in 2012, what is your plan to get to 10 weddings and 50 seniors for 2013? It's not going to happen by accident or luck. And I sure hope you're not just using Facebook and referrals to make it happen. Don't get me wrong, these things are helpful, but you have to have a solid marketing plan in place.

▸ **Communication strategy.** How are you going to reach your potential customers? You need a multipronged approach—social media, brochures and flyers, vendor partnerships, advertising, press releases, and so on.

Your overall sales strategy should include a sales force strategy and sales activities. Let's look at each in turn.

Regarding your sales force strategy, how will you run the sales process for your business? These are big decisions for your company and will ultimately impact your revenue streams. Now, sales strategy in our industry typically refers to two different parts of the process. In the first part, you're selling them on working with your studio. Maybe it's a wedding you're after, and you're selling the benefits of booking in the studio. Or it could be a portrait session, where you're selling them on booking a session with your studio. This part of the process can happen on the phone, in the studio, or in a meeting space.

Regarding the initial booking, who will do it? What will the process be? Will it be you as the principal or will you hire someone? If you hire a full-time person, how will they be trained? These are things that you must think about ahead of time.

The second part is focused on the post-event sale. Now that they've had their session and it's time to purchase pictures, what's your strategy? Will you handle this process online, in-studio, or in the client's home? Here's where you need to get a little more granular on the sales process. What does the sales process look like and how is it executed? Let's break it down by task.

For weddings I shoot, here's a typical workflow:

1. A phone call or email comes in requesting pricing information.

2. A response email (using our customizable template) goes out with general information, asking the potential client to a meeting in our studio where we can showcase our products and services in a face-to-face meeting.

3. The client books or requests more time to decide.

4. If we don't hear from the client, we follow up with an email 24–48 hours after the meeting.

5. Either the client books or we move on to the next opportunity.

You can see in this simple sales process that we have clear activities for each step in the process. This is a process that has been refined over the last four years. It's simple to execute and not overly sales-y. There's no right or wrong answer here; just take the time to map out your process and adjust if it's not working.

Service or Product Line

This part of the business plans involves creating a description of what exactly you're selling. As simple as this might seem—with an answer like "photography"—you need to drill down and get specific about what you're selling and the benefits for potential target customers.

Include a description of your product or service. You have to think about the benefits of your product or service from your customer's perspective—not yours! If there's no discernible difference to the client between your product or service and that of your competition, then it doesn't matter what you think. It's the client's dollars and desires that should dictate success or failure, not how we feel as artists about our work.

For example, for the senior photography side of our business, I provide the following as a description of our service:

"We offer a once-in-a-lifetime model experience for our high school seniors, complete with hair and makeup and a photography style that screams individuality for our clients. Clients looking for the ultimate in senior portraiture will be treated to larger-than-life imagery that will be shared and enjoyed for years to come with our lifetime warranty and archival products."

Now, I could expand on this even more if I chose to. That's up to you, but I'd say—and I hope you agree—I'm very aware of the value proposition we offer our high school senior clients.

Financial Projections

Once you've taken a good look at the market and developed your goals and objectives, it's time to start thinking about financials. This document covers your historical numbers, as well as future projections based on the business landscape. If you're just starting out, obviously you won't have much, if any, historical data for your business—and that's okay.

I'm going to steer away from the typical or more traditional way of completing this section of your overall business plan and offer my own way of doing this. I'll describe how we approached this step when we started our own company and how I work with other photographers we're consulting with.

How much money do you want to gross? Basically, how much do you want to make? Sounds crazy, right? However, I firmly believe that we all have this amazing opportunity in front of us and we're limited by nothing but our own fears. We create the box of limitation. And right now, I want you to think outside that box.

Let's start with a reasonable number. Because the average photographer grosses about $45,000–$50,000 per year according to most industry numbers, let's start with $150,000. This is a great place to begin; at three times the average photographer's take, it's a huge growth number but it's most certainly achievable with a solid business plan.

Great. Now, let's break it down.

Say you can do 25 weddings at $4,000 average and 50 portrait sessions at $1,000 average. And it's that simple! This is now an achievable financial projection and should be part of your new business plan.

Next, how do you get there? That strategy should be defined in your marketing and sales plans. But these are real numbers that I think are attainable. The average wedding photographer can get about $3,000 contracted average. That leaves you with just $1,000 more to earn per wedding. Can you arrange a $500 engagement sale and a $500 spend after the wedding on features like an album upgrade, framed prints, or canvas? This figure will be tied to your sales strategy.

Everything you do in your sales and marketing plans has to be tied to making these numbers happen. All these documents must work with and "talk to" each other; after all, they all add up to become your comprehensive business plan. For example, looking at these financial projects, you know that you can't offer a wedding package for $500 and think you're going to hit a $4,000 average per client.

This is just one example. Try this with your own niche of clients: boudoir, architecture, children, pets, landscape. It works with every style of photography or business.

Next Steps ▶▶▶

Where do you go from here? I want to see you lock yourself in a room for an entire day with no access to email, cell phones, and everything and anything that's shiny and that could ultimately distract you. Create your business plan. The first time you do something like this will be the toughest, but in the end, this document will provide you and your business with some marching orders.

Go through each section of this chapter and put your own dreams and aspirations down on paper. Force it to become real. Seeing the written word is much more powerful than just saying you're going to do something. Focus on every aspect of this chapter until you complete your plan.

Once completed, the business plan becomes your manifest destiny. Everything you do should be related to your mission, business plan, and marketing strategy. If it's not, then you are getting sidetracked and need to refocus your energy. That said, keep in mind that it's not uncommon to revisit your plans yearly. We do.

four

Branding

TODAY, ALL PEOPLE talk about is branding, branding, branding. But what does it really mean? In this chapter, you'll drill down into branding and discover what it means for you and your business. Without a doubt, branding is one of the most important facets to your business; without it, you run the risk of getting lost in a sea of photographers. Think about some of the brands you know and love. Are they exclusive brands or low-cost providers? Which do you want to be? Let's find out!

What Does It All Mean?

It wouldn't be a business book if we didn't open up with the standard definition.

Branding. According to Wikipedia, a brand is a "name, term, design, symbol, or any other feature that identifies one seller's good or service as distinct from those of other sellers."

Right now, you might be thinking, "That's great, Sal, but what in the world do I do with that?"

Understanding the term helps you start thinking the right way about branding. And by "thinking the right way," I mean thinking beyond your brand. See, my philosophy is simple. Wherever we go, branding is slapping all of us in the head. Sometimes this is obvious whereas at other times it's very subtle. But, I promise you, it's there.

Now that you understand the definition, I want you to start looking around at everywhere you go, everything you read, everything you listen to, and everything you watch. Just being honest, it's in the bathroom, too! Think about what you're seeing, what you're being influenced by, and how it's altering your behavior and decision-making process.

If you can understand how branding impacts you, you'll quickly realize how it's impacting your customers and their decision-making process when selecting a photographer or ordering products.

This is important stuff. Take notes and start thinking about how you can incorporate these concepts into your business.

Defining Your Brand

An effective branding strategy gives your business a leg up on the competition. Think about it: photographers are everywhere. From the consumer's perspective, it's a daunting task to select one. What makes your business stand out from the crowd? Did you know that your brand is not only about your logo or website? As you'll see later in this chapter, everything will

define your brand—from the way you pose your clients to the editing techniques you choose in postproduction. You have to be able to establish yourself in the marketplace and stand out from the crowd.

In order to define your brand, let's embark on a little exercise. Back to the pen and pad. Here we go:

‣ What is your company mission? Your vision?

‣ What are the benefits and features of your products that differentiate you from your competition?

‣ What existing perceptions, if any, are there about your brand? (This is important if you're an established studio trying to reinvent yourself.)

‣ When people think of your brand, what do you want them to think or feel?

Once you've answered these questions, you can start putting together a better picture of your brand identity.

For example, our studio is perceived to be expensive in our market. I am okay with that. That's part of our brand. There's a set of perceptions that comes along with higher prices. (Better quality and better service are just two of them.)

Now, I'm not naïve. I get it. Just because you're more expensive doesn't mean you are better in any way, shape, or form. In fact, I bet we all have personal experiences in our lives that we can draw on where we've paid more under this pretense and been let down. However, as cliché as it sounds, perception is reality. We can look to examples in the real world to support this—Louis Vuitton, Mercedes-Benz, Lexus, Tiffany, True Religion, and a host of other high-end brands. The people who can afford these brands love them. They offer a high-end, rich, unique experience and product, and guess what? People are willing to pay a premium for that level of quality and service.

Let's go the other way with this example—Wal-Mart, Volkswagen, Kia, Odd Lots, Old Navy. These are perceived as value brands, offering average or below average quality at a cheap-to-reasonable price.

What's your personal perception of these brands? Would you ever go into Wal-Mart and pay over $200 for a pair of jeans? Probably not. Do you know

why? Because the average consumer has preconceived notions about the quality of product and the price point when walking into a store like Wal-Mart, and they'd more than likely reject a product in that price range. The same would happen on the other end of the spectrum, by the way. If a high-end consumer walked into a Louis Vuitton store and was presented with a $10 pair of sunglasses, they'd immediately assume the glasses were of inferior quality; ultimately, those sunglasses *would*—not could—have a negative impact on the overall brand.

So let's step back here and apply this to your current world. What does your brand say about you? What category do you want to play in? Do you want to be seen as an artist offering a unique product or service, or would you rather appeal to the masses providing the low-cost solution to professional photography?

If you chose the latter, I suggest you put this book down. It's not for you. You'll be out of business in the next 6–12 months and you'll never be able to take care of your family, buy new equipment, or retire. Sorry. That's reality. I know what some of you must be thinking or feeling right now: "Wow, Sal, that's harsh!" You know what, it is harsh. It's harsh, it's reality, and it's tough love. When I started writing this book, I wanted to help photographers who want to make a career out of this amazing skill we have. This skill is not meant to be mass-produced. As an artist, your vision is tied directly to you. And do you know what you are? A very limited resource. There's only so much of you to go around. You can only shoot so many sessions per year. Show me another product or service based on limited resources that is mass-produced and cheap. After you're done thinking about it and realize there are none, let's get moving. We have a business to build for you!

So, as we move forward, here are a few more questions to ask yourself:

▸ What segment of the market do you want to go after?

▸ What will you do to stand out from the crowd?

▸ Does your current brand support this vision?

Let's assume you have some work to do here. And let's start looking at how to define and create your brand.

The Obvious Pieces

When you're putting your brand together, there are some obvious pieces and some not-so-obvious pieces that go into your brand. By obvious, I mean that you see these every day with the brands you know and love. To a certain extent, some of the obvious ones might be so subliminal that you don't even realize you're being targeted by someone's brand.

What are the obvious pieces of a brand? They're the basics that most people should think of when they're defining their brand. The following list isn't exhaustive, but it will surely get you off in the right direction:

- Name
- Logo
- Tagline
- Graphics
- Colors
- Sounds
- Blog
- Facebook
- Website
- Marketing pieces
- Packaging

Let's explore each of these, but before we do, I want you to indulge me in a little exercise. I want you to pick three words that best describe your brand as it stands today. In fact, take it a step further. Have people close to you offer words that best describe your brand through their eyes. This is going to be tough to listen to, but it's for the betterment of you and your business.

Now, I want you to select three words that best describe your brand as you want it to be seen in the very near future. For our business, we chose *creative*, *stylish*, and *award-winning*.

Why are these three words so important? Because they should dictate everything you do from this point on as it pertains to defining and creating your brand. You need these terms to drive your name, logo, tagline, and all the other items on your brand list. You can't describe your brand as creative and then have a noncreative logo. Use these keywords to inspire your business and the next steps.

Name

Easy, right? Just pick a name and let's go. Holy cow! Stop the madness. As you can imagine, I see lots and lots of business names, and I knew that for this book, I had to write a little section on what goes into a name.

Ladies and gentlemen, this is it! This is the first thing most people will speak when they're speaking of your brand. Choose wisely. I think you have two options here. Either go with your personal name or select a unique name altogether. Each approach comes with its own set of pros and cons.

Select your own name and the business is tied directly to you. You become the face of the brand. Your brand will live and die by you. We set up our business to be Salvatore Cincotta Photography. The brand is inextricably tied to me. This is great news if you're building your brand to be a limited-resource high-end artist. However, what happens if you ever try to sell your business? What's your exit strategy? I have news; it's going to be near impossible for me to sell my business with this name. But in the meantime, I'm able to charge a premium as an exclusive photographer. Plus, it doesn't hurt that I have a unique name.

What if you select a somewhat generic name? You run the risk of being perceived as a generic box store of sorts. This becomes a challenge as you try to build your brand and charge more for your services. On the plus side, you can add and subtract photographers without impacting your overall brand, and best of all, you can sell the business at some point if you choose to.

Whatever option you choose, please do me a favor and take some of my advice. Leave religion, politics, and hobbies out of the name. No one cares that you're extremely religious, or that you're a Republican, or that you love dancing pigs. If you do something like this, you immediately alienate a part of the market. And the one thing you need to understand as a business person is that you don't want to accidentally alienate any segment of the market due to race, religion, or politics. Saving Grace Photography: no! Right-Winged Photos: no! Funky Town Express Studio: come on. I hope you get where I'm going with this. Think about your name, and most importantly, think about how it's going to be received by the consumer. Better yet, look to corporate and find an example of an extremely successful brand that incorporates race, religion, or politics into their names that aren't related to companies that are race or religion, or politically tied.

Your name will dictate and influence the perceptions about your brand. Choose wisely and ask people you can trust for their honest gut reaction.

Logo

I know. You have Adobe Photoshop and Illustrator and now you're a professional graphic designer. They must feel like we do, don't you think? Everyone has a camera and now everyone is a professional photographer. Just because you can doesn't mean you should. Let the pros do their thing. They understand the importance of a good logo. Your logo will be everywhere—your website, marketing material, and so forth. It's worth the $500–$700 that it'll cost you to get it done.

Salvatore Cincotta

The logo should match the personality of you and your business. Things to consider: Do you want to be super artsy with it? Clean and simple? Work with your graphic artist and ensure he or she has those three keywords that describe your brand.

Tagline

Closely related to your logo is the tagline. The tagline can be a simple one-sentence descriptor that conveys the essence of your brand. Don't overthink it, and don't make it corny. And again, it should match the overall tone of your brand.

We used our three keywords as our tagline. "Salvatore Cincotta Photography/ Creative. Stylish. Award-Winning." For us, that was perfect. Clean, simple, and to the point.

Graphics

Graphics are the elements you choose to incorporate into your logo. A graphic can be as simple as a flower or as random as the ribbon on a can of Coca-Cola. This element is not a must-have. It should complement your logo and add to the overall look and feel of the brand. If not, then you just might be forcing it.

Our main logo, Salvatore Cincotta Photography doesn't include any graphical elements. However, one of our logos for our top-end clients, Black Label, does incorporate graphics into the logo to give it a richer look and feel.

Colors

As odd as it may sound, the colors you choose are also tied to your brand. I don't know that there's a right or wrong answer here. However, I do think you need to consider colors before moving forward with logos, website design, marketing material, and so forth.

A question worth asking: Who is your demographic? If you're a family photographer, you're more than likely targeting families. If you're targeting families, typically mom is the decision maker. Therefore, I suggest that your brand, logos, colors, tagline, and so on be geared more toward women. Now keep in mind that you run the risk of alienating men, but in this case, maybe the pros outweigh the cons.

In our business, we target weddings and seniors, and those are two very different demographics. So, rather than focus on any single one color, we opted to remain neutral in our design, colors, and use of graphics.

Sounds

Really, Sal? Sounds? Yes indeed. Even the sounds you select for your website, hold music, studio music, and slideshows impact and define your brand.

Companies like Apple spend millions of dollars perfecting the right sound for when you turn on your computer or send an email, or when an error message pops up. Next time you get into your car, pay a little more attention to the sounds your car makes when you put the key into the ignition, put the car in reverse, or take any other actions. It's even more pronounced when you go from a car about 10 years old to a new one. You can hear the difference in a significant way.

For us, we opt to only have music on our site with slideshows. We feel it sets the tone and gets people in the mood to watch our portfolio slideshow. I use a company called SongFreedom.com to get legal access to mainstream music for my website. There's nothing worse than going to a website and listening to 1980s keyboard music. That's not my brand or my demographic. Is it yours?

Blog/Facebook/Website

I have lumped all three of these together not because they are necessarily the same things, but because they are all geared toward the same audience in a digital way.

Certainly the graphical pieces are important to your brand; that's a given. The piece that most people don't even think about is the voice. No, not your actual voice—your written voice. See, when you write, how you write, what

you write about—that becomes your voice and ultimately becomes part of your brand.

I'm going to level with you. No one, and I mean no one, cares what you ate for breakfast, or about your philosophy on manicured lawns or the host of mundane thoughts you have rolling through your head on a given day. Okay, maybe your mom cares, but beyond that, no one.

Your social media presence should not be your soapbox. Believe it or not, people come to your site to see great images! To be inspired. To hire a great photographer. So, rather than talk about what you ate for breakfast or your bike ride, give them what they want: great images!

Don't get me wrong; I've heard from all the "experts" in our industry about how such personal ramblings allow the clients to see who we are as real people. Um, maybe it's just lost on me, but I gotta be honest here. When I walk into a restaurant, I want great food and great service. I don't want to know too many personal details about the chef, what movie he recently saw, or why he loves baby kangaroos. I want to know things that are relevant to my meal.

Now it's your turn. When you select a product or brand, do the daily tribulations of the CEO influence your buying decisions? Or do you make your decisions another way? I'd be shocked if you told me you selected a pair of jeans because you heard that the CEO of The Gap liked yellow jellybeans.

Be conscious of your social presence and what information you're pushing out to the masses. If it doesn't help your brand, it's definitely hurting it.

Marketing Pieces

Whatever marketing pieces you put out there—whether they're flyers, direct mail pieces, or point-of-sale displays—should all be tied back to the brand, the logo, the colors, and other elements. If you have a corporate-looking brand—clean and simple—then putting together a marketing piece with frilly flowers and design elements might confuse your client base and they might not even realize it's your brand.

Nike is a perfect example of a branding machine. It's all about the swoosh. Their marketing is clean and simple. It matches the overall brand. They let the product (and typically the athlete) speak for itself; the swoosh is there just to reinforce the brand and the message. Just Do It.

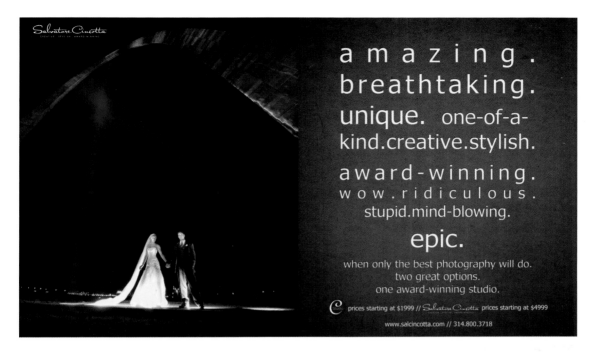

Salvatore Cincotta

a m a z i n g .
breathtaking.
unique. one-of-a-
kind.creative.stylish.

a w a r d - w i n n i n g .
w o w . r i d i c u l o u s .
stupid.mind-blowing.

epic.

when only the best photography will do.
two great options.
one award-winning studio.

prices starting at $1999 // Salvatore Cincotta prices starting at $4999

www.salcincotta.com // 314.800.3718

In our studio, we try to ensure anything going out is recognizable by our customer base. We spend a lot of money on marketing and advertising, but if no branding is tied to it, then all that effort and money has been lost. No one will remember who we are or that the message was tied to our company. Be sure to invest in marketing collateral that's cohesive with the overall vision and brand.

Packaging

Packaging is a tough concept for most studios. I see a lot of people I work with struggle with this one. You make a huge investment in the product—perfecting your craft, the right equipment, your logo, and your website—and then you drop the ball when it comes time to deliver your products to the consumer.

You can't be the Louis Vuitton of our industry and deliver your products to the client in a plastic polybag. When you do this, you're saying, "Hey guys, I know you spent a lot of money with us. Here's some junk I have for you to take home."

Louis Vuitton probably spends more money on their packaging and delivery of their product than they do on the actual product. I'm only half joking

here, but seriously, their packaging is like no other I've ever seen or experienced, and there is a good reason for that. They charge a premium for their products.

Our studio has tried to adopt a similar philosophy when it comes to delivering product to our clients. We hand-deliver products to our high-end clients and blow them away with our level of service. As far as packaging goes, we've spent a considerable amount of time and money creating a richly branded packaging experience so our clients feel as though they're getting the most precious of gifts.

The Not-So-Obvious Pieces

Wow. We covered a lot of things and I'm sure I have your head spinning right now with new ideas and concepts to consider. And that's awesome! That's what this is all about. Let's shake things up in your business.

Before you get too far down the rabbit hole, I want you to start thinking about a few things that aren't so obvious when it comes to branding. I find a lot of people don't think about these things at all, or if they do, they just don't care enough to give them the time and attention they deserve. I promise you, pay attention here, because this is just as important as everything I listed earlier, if not more so:

- ▸ Your dress
- ▸ Your personality
- ▸ Posing styles
- ▸ Editing techniques
- ▸ Lighting techniques
- ▸ Product lines
- ▸ Pricing

We'll explore each of these factors to show how you can make changes in your business and how they currently might impact you in either a positive or negative way.

Your Dress

Yes, the way you dress matters. You want someone to spend thousands of dollars in your studio, but you want to dress like a slob? Don't get me wrong; I'm all about hanging out in jeans and a t-shirt, but this hipster look

that's in right now is not going to bode well for your business. The way you dress says a lot about who you are as a person.

Don't believe me? The next time you walk into a store, don't talk to anyone; just look at the person working at the counter. In fact, you should put this book down right now and go do this. This is an important exercise.

Walk into Wal-Mart. Walk into McDonald's. How are the people dressed? What's your perception of them? Now ask yourself, would you trust them with $5,000–$10,000 dollars to document the biggest day of your life? To document your child's wedding day? Why not, just because of the way someone is dressed?

Is it superficial? Oh, without a doubt. I'm not endorsing this way of thinking at all. In fact, I try with every ounce of energy I have not to pre-judge people. However—and this is a big however—this is the world we live in. So, I'm not going to stick my head in the sand and pretend it doesn't exist. I know when people walk into my studio, they are judging me—consciously or subconsciously—within seconds. I'm aware of it and I make sure that when I'm meeting with clients I'm dressed appropriately for my brand. Creative. Stylish. Award-Winning. You don't show up in a tuxedo and you don't show up in cargo shorts and flip-flops.

Your Personality

Minds are being blown right now. "Wait, first you tell me the way I dress matters and now you want to tell me that my personality matters? Won't people just hire me because of my art?" No. No, they won't. They're hiring you just as much for your personality as they're hiring you for your art. In fact, though most of my clients are drawn to my artwork, I believe most hire me because of my personality. That's without a doubt my X-factor. When it comes to wedding clients, they're more than likely asking themselves, "Can I spend 8–10 hours with this person? Sure, he seems like he'll make the day fun and exciting."

Again, this is reality. If I were hiring someone for my big event, I'd surely want to have fun with them. If their personality sucked, then there's a good chance the pictures aren't going to be good. As we all know, there's an art to getting people to respond to the things we need them to do in front of the camera.

Our business is different than other businesses. We spend significant amounts of time with our clients, so personality is a major consideration. Keep your energy level up, don't talk about yourself (no one cares), listen to the client, ask lots of questions about them and what they're looking for, and you'll be well on your way to winning over clients.

Posing Styles

The way you pose your clients says more about your studio than you can imagine. I look at websites all day long and I can see a traditional photogra- a mile away. Which, by the way, isn't a problem if that's the client you're However, I'm going after the young trendy bride; those are the ey to spend and who love photography. If I were to showcase ses on my website—but have a cool site with a cool new logo— ng my potential clients mixed messages. And they'd more than k elsewhere.

g is a tough thing to figure out. Do you direct your clients or do you let them do their own thing? When is there too much direction? Every photographer has a different style of directing. There's no right or wrong answer here. Just be consistent with your posing and make sure you're targeting the right clients.

Editing Techniques

Today's client is becoming more and more tech savvy. This is a trend that will continue as time goes on. Kids are exposed to iPhones, editing tools, and a host of plug-ins at a very early age.

I have moms asking me to use "the skinny tool" on them. They understand HDR, vignette-ing, and a host of other techniques that were once only understood by the most technical of us. We have to adapt or die.

Sure, we have to create a good image in camera. We have to understand exposure, lighting, and composition, but we can't deliver printed images in an unpolished fashion. We color-correct, soften skin, and use a host of plug-ins to create a unique and artistic look for our images and our clients. Without this, our clients are going to have a tough time looking at our images and seeing them as "art" when they truly believe they can go buy a camera and

take the same images on their own. Editing techniques allow my studio to stand out from the crowd.

Lighting Techniques

Closely related to editing are your lighting techniques. The easiest way for a professional to stand out from the weekend warrior is to use off-camera flash. This strikes fear into the heart of the average photographer. New photographers—and not all of them—typically grab a camera, slap that bad boy into "P" for Pro, and they're off to the races, basking in all that glory we know as natural light. Awesome, but what happens when it gets dark? You done for the day? What happens when you can't shoot during that gold hour? You go home?

I shoot 12 hours a day in nearly any lighting situation. Not because I'm great, but because I'm a professional and committed to my craft. Sure, it's a little more complicated than natural light, but take some time and practice, practice, practice, and you'll get the gist of it. Soon, your images will have a distinctive look and feel that separates you from the crowd.

There's a never-ending supply of lighting toys available to us, from reflectors to continuous lighting sources. Use whatever works for you. Get out there and play! And most of all, don't be afraid to make mistakes.

Product Lines

If you want to be a high-end studio or brand, then you have to offer the appropriate products to your clients. All too often—typically because you aren't charging enough—studios offer the cheapest prints, the cheapest canvas, and the cheapest albums. Well, guess what? You're never going to be able to charge a premium until you start carrying products that command premium pricing.

Again, we don't have to look far to see this in practice. Think about something that you're into. A hobby, for example. I'm into golf. I love it. I don't play enough, but I love it nonetheless. I can buy a set of clubs for $89 and I can buy a set for $1,999. I guess to a certain extent they all do the same thing; they allow me to strike the ball. However, there's a plethora of features that make the more expensive line, well, more expensive. Bigger sweet spot to

allow me to hit the ball off-center. Strong club shaft. Better grips, custom fit to my height, and so forth.

Maybe golf isn't your thing. What is your thing? And what do you like about one product line offered by a company compared to another? Your potential clients are going to be asking the same thing. And if you find that sweet spot, you're going to be able to charge a premium for that product or service.

Albums are probably the number one product we offer that allows us to stand out from the crowd. And you could make the argument that a book is a book is a book. Well, when you come to our studio and you get to see and feel our books, it becomes something a bride has to have. The leather is like no other. We offer crushed-velvet liners versus a standard black paper liner. The covers are something most other studios won't carry because it's more expensive to get samples. The sizes we offer are also unique. One of our most unique sizes is an 8x20. Clients love it!

If you want clients to perceive your brand as a high-end brand, you have to have products that are perceived as high-end and exclusive to you. What makes them unique?

Pricing

Ah, yes. Pricing. The archnemesis of almost every artist around the world. This can make or break you and your brand. Charge too little and you risk being perceived as just a guy/gal with a camera. Charge too much and you risk pricing yourself out of the market. Though we won't explore pricing models and strategies here, I will tell you that how you price your work will have a profound impact on the success or failure of your business. We try to price our session fees and products so that we appeal to the middle through higher end of the market.

Don't underestimate this part of your business. Every time I sit with a photographer, they say the same thing. "I can't raise my prices. The clients I have now are already complaining I charge too much!" Right. That's because you're going after the wrong clients. You're priced too low and therefore attracting the client who wants quantity versus quality. Trust me—raise your prices, and you'll start attracting a different caliber of client.

Pricing is directly related to the perception of your brand. Within our local community, people know we're a high-end studio and they treat us differently because of that. They treat us like, well, artists.

What Is Your X-Factor?

When it's all said and done, your brand is your X-factor. All the pieces have to work and flow together to create a cohesive look, feel, thought, and experience. It's hard work, for sure, and it's never over. We work on our brand nearly every day. In everything we do, we consider how it impacts the brand. I encourage you to spend a significant amount of time working on this part of your business. Yes, we have to be shooters and students of our craft, but we have to be students of business, too. There's no better place to look than corporate America for inspiration. These are companies that spend millions of dollars working on their brand. They have it figured out. Who am I to argue with them? I just want to find a way to incorporate some of their techniques into my own business. So should you.

Next Steps ▶▶▶

I want you to try a little exercise I have done in the past with great success. I want you to consider having a focus group discussion with some of your clients, both past and present—maybe even friends. Offer them a free photo session to participate. Have dinner or pizza brought in and make it fun. Shouldn't take more than an hour of their time. To get them excited, thank them for being great clients and let them know you're going through a branding reboot and wanted to pick their brains for an hour for some honest feedback.

Before the meeting, list the five key words you would like your brand to be known for. Creative. Stylish. Award-Winning. Luxurious. Rich. Come up with whatever matches your brand as you'd like it to be perceived. Take that piece of paper. Fold it. And put it away for now.

At the meeting, once everyone gets there, keep it relaxed—eat, drink, and just chat away. After about 30 minutes, kick off the meeting. Explain to everyone that you're looking for honest feedback because you're trying to take your company and your brand to the next level. Then, project your logo on the screen at your studio or print it on a single sheet of paper. Have everyone write down three adjectives that describe their thoughts about your logo. No need for them to write their name down. Remember, the goal is to keep it stress-free and get honest feedback.

Do the same thing for your website, for your packaging, and anything else you want honest feedback on. Then compare the feedback with that folded piece of paper you created. The feedback might really shock you and open your eyes to one major issue: Your perception of your brand might be skewed compared to that of your clients. And that's a huge problem that needs to be rectified immediately.

The Marketing Plan

AT TIMES, MARKETING seems to be this nebulous thing, and photographers tend to misunderstand the full extent of marketing. However, just like your business plan, without a marketing plan, you're walking around in the dark hoping someone will find your business and spend money with you.

A marketing plan outlines the company's overall marketing efforts. The plan can function from two perspectives: strategy and tactics. Your best bet is to formalize this process; it's the only way to ensure that you're executing according to plan and that the entire organization (even if that's just you) is marching to the same beat.

In this chapter, we'll explore the purpose of a marketing plan along with various marketing options—from Facebook Ads to direct mail—and determine which option will work best for you.

Marketing Defined

According to Wikipedia, *marketing* is "the activity, set of institutions, and processes for creating, communicating, delivering, and exchanging offerings that have value for customers, clients, partners, and society at large."

In English, *marketing* is all those activities that help communicate the value of your product or service to customers. The goal is to bring together buyers and sellers for a mutually beneficial exchange.

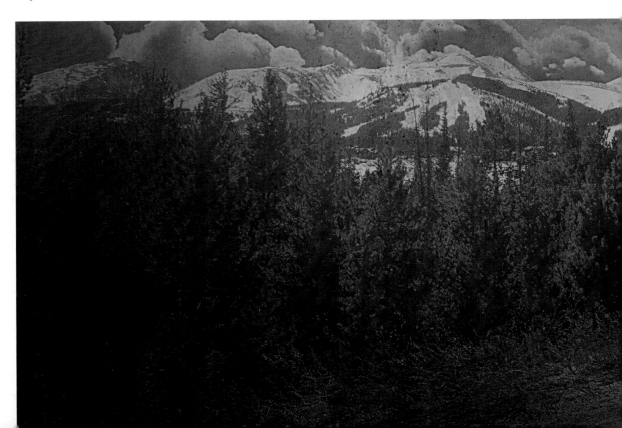

Many people mistakenly see marketing and advertising as two separate tasks or disciplines. Nothing could be further from the truth. In fact, advertising is a component of your overall marketing plan. It's the part that involves getting the word out to your market.

Think of marketing as a pie. Many pieces of that pie create the whole. The marketing pie is made up of advertising, public relations, sales strategy, branding, customer support, and pricing, just to name a few. All of these things require you to think and plan accordingly. You can't haphazardly execute these or worse yet, ignore them altogether.

In our studio, we spend a lot of time marketing. We reevaluate our marketing plan every 4–6 months. It's not a painful process. We keep it nice and simple. Taylor and I will sit there, evaluate what has been working, and try our best to tie a dollar amount to it. Keep in mind that not all marketing and advertising tasks can be accurately measured. Sometimes, success is defined by just creating more brand awareness versus ending with an actual traceable sale. Anything that doesn't appear to be working, we decide as a team if we want to continue and give it another try, or pull our dollars and reallocate them somewhere else.

And by the way, don't make the mistake of thinking that some ad or service costing "$0" means free. It's never free! There is time, and time is one of your most valuable resources, so be sure to evaluate wisely.

We then spend some time looking at new opportunities that are out there: Facebook, Twitter, and direct mail, among others. It's a great exercise, and as a team we push back and forth on each other seeing if we can find holes in the plan. But this plan is, again, a living document. You should have noticed by now that for me, nothing is written in stone. As an organization, you have to continuously adapt or you'll die. It's that simple. The roadside is littered with photography studios, along with many other types of businesses, that refused to adapt.

Marketing Options

Here I want to explore the various marketing options that we use in our business. When you're first starting out, a marketing budget is almost an oxymoron. You don't have money to market because you aren't generating enough income, and you aren't generating enough income because you don't have money to market. It's a vicious circle; trust me, I know.

When you're just starting out, you need to get creative. Now more than ever, guerilla marketing tactics (boots on the ground, networking, word of mouth, and free) are going to be critical to getting the word out. If you're an established studio, you have to explore each one of these options to best determine your return on investment (ROI). Every market is different and every studio will have a different level of success with each item listed. We tend to spend approximately 10 percent of our gross sales on marketing efforts.

Press Release

Cost = Free Time = Low Return = Low–Medium

We love press releases. This is the easiest and simplest form of advertising. People today often ignore press releases as an option, but I'm telling you, clients still read newspapers. It's a great way to keep your name out there, and every once in a while a local news organization will pick up the story in

their paper. That's all good news for you. Even if you don't see a whole lot of return, you have to remember that it takes no time at all to draft these things.

To make the best of this approach, download a free press release template from the Internet. There are thousands out there for you to use for free. Once you download a template, customize it to your brand with your logo, address, and so forth. Then you'll have your own customized template.

Next, compile a list of local contacts that carry business or local interest stories. These are key contacts for your business. Look online for blog sites, newspapers, and various media outlets.

Every time something happens to your business that's somewhat newsworthy, put together a few paragraphs and send the information to your list of contacts in the area.

For example, you could draft press releases for specials or promotions you're running, accomplishments or awards, a fun shot you created, or charities you're working with. These all make great opportunities for you

to promote your business and get your name out there. If nothing else, it keeps your name in the limelight.

Recently, we had the opportunity to photograph President Barack Obama. You know I put that out everywhere we could. It created quite the buzz for us locally and all our clients knew about it. Think about what this did for our brand. It told existing clients that they made the right decision in working with our studio. I mean, after all, if the White House selected us, we must be doing something right. It told new prospective clients that we were the real deal and, ultimately, helped justify our price point.

Don't underestimate the press release as a tool for your business.

Television

Cost = Very High Time = Low–Medium Return = Low

Television has made many people and companies rich overnight. Unfortunately, I have tried television several times with little to no return on my investment. You're free to explore TV ads as an option, but I warn you, this could be a costly mistake for your business and your wallet.

Without a doubt, television has the ability to get your message to a large and broad audience. However, television has the ability to get your message to a large and broad audience. Yes, I said the same thing twice. What I love about television is also what I hate about it. You have little control over the message and little control of the viewer. Are you like me? Do you watch commercials or fast-forward through them? Nine out of ten times, I fast-forward through commercials.

Don't get me wrong; it was cool seeing my work on local TV, but it didn't make the phone ring at all! I give this a major fail for our line of work.

If you're interested in TV ads, the first thing I recommend you do is get a media kit from the television station. They can tell you about the cost, when and where the ad will run, and who the target demographic is. Who knows, maybe you will have better luck than I did, but proceed with caution. I truly believe there are better ways to burn through some advertising dollars.

When it's all said and done, you'll be building brand awareness for your company, but at what cost? That's the question you have to ask yourself. We all have different tolerance levels for risk.

Direct Mail

Cost = Medium Time = Medium Return = Low–Medium

No, direct mail is not dead! We use it all the time with great success. Now, I won't tell you it works with every type of client or niche you're going after. But if used correctly, direct mail will help drive brand awareness and make the phone ring. We use it every year.

Let's understand a few things about direct mail. First and foremost, it's not a silver bullet. You won't become rich by sending out a few flyers. Nor can you do it once. I like to think of direct mail as more of a slow-and-steady kind of campaign, one where you're putting out specials and information a bit at a time.

Understanding the numbers is also important in defining success with direct mail. According to various sources and just personal experience, almost 80 percent of households will read or scan mail pieces. Good news, right? Well, it all depends on how you define good news. You'll only get a response rate of about 3.5–4.5 percent. Yes, that's correct. All that money and you can expect fewer than 5 out of 100 to respond.

Before you freak out and declare direct mail a failure, understand that direct mail accomplishes several things. It creates brand awareness, getting your name on the tip of the tongue of your client base. In addition, it will get the phone to ring, which is ultimately the goal, right?

What about cost? You have to consider buying a list of names (there are companies like American Student List and InfoUSA that provide names by demographic), postage, and the cost of printing the card. We like to use an oversized card to ensure ours doesn't get lost in the mail. It's a little more expensive, but it's worth it. Total cost is usually about 85 cents to a dollar per card.

If you choose to do this, do it right or save your money. The rule of thumb is you need to touch people 3–5 times before you get them to respond. So, you can't just send one card and hope it works. In addition, you need to make sure the card has a powerful message, images, and a strong call to action.

Charities

Cost = Low Time = Low–Medium Return = Medium

Charities are a great way to get your name out there, give back to the community or a cause, and are relatively inexpensive for you to participate in. When we were starting out, we participated in about 20 different local charities. It was an awesome feeling to know that we were helping organizations raise money for a great cause, in addition to building our business and client base. It was the best of both worlds.

There are all sorts of ways to participate with charities; I'll give you my opinion and strategies here. Ultimately, I suggest you experiment and see what works for you.

The only way to make something like this work financially is to ensure you have a way to recoup money by getting to the sale with the client. For example, a great option for a charity event would be to give away a free family session. Note that you're giving away a session—not the digital negatives, 16x24 canvas, and the kitchen sink. You'll be shooting yourself in the foot if you do that. People will think they don't need to spend money and assume they have everything they need in the package they have won or purchased. By giving away a session, the message is clear: no pictures are included. This allows you the opportunity to get some sales out of it, which is ultimately the goal. You're in business and have to make money.

The next thing to consider is a "use-by" date. The entire point of this marketing exercise is to generate some new business. What good does it do for you and your business if you give this great gift to someone and it sits in a drawer for a year waiting to be redeemed? You need to get them into your studio in front of your camera so you can create some great images.

Let's take it a step further. What I like to do is ask the charity to give me the name of the winner so we can call them immediately to get their session scheduled. It's a prerequisite for me to participate in the event.

Magazines

Cost = High Time = Low Return = Low–Medium

Magazines are another form of creating brand awareness. It's not going to make you rich, but it is something that needs to be there in conjunction with other forms of marketing. It's critical to a multiprong marketing approach that will help grow your business.

Before you start advertising in magazines, choose wisely. Make sure you're reaching out to magazines that are hitting your demographic. There's no sense in advertising your wedding photography in a family magazine. Every magazine should have a media kit for you, listing their audience demographics, income levels, circulation numbers, and similar information. All these things should factor into your decision and, ultimately, factor into the cost of advertising. Don't mistake cost for quality. I've had the opportunity to be in some of the most exclusive magazines and paid $10,000 for a full-page ad with no results. I've then advertised in mid-range magazines for $2,000 per page and booked 4–8 weddings.

Whatever you decide to do, make sure your ad is powerful. Put your best work in there and have it designed by a professional. The worst thing you can do for your brand is to slap some pictures on a page with poorly selected fonts. It looks like a mom-and-pop ad and it sends the wrong message. Your ad should evoke some sort of emotion and get clients to take action.

Blogging

Cost = Free Time = Medium Return = Medium

Sure, you may have a website and even one of those fancy blogs set up, but are you using it? It pains me to go to photography blogs and see that the last entry was posted three months ago. Do you understand the message you're sending to your clients? You aren't active, you aren't busy, and you must not be a very good photographer.

If you're going to create a blog, then get out there and blog! This is your opportunity to have a voice. A voice in the community. Prove to the community that you are, in fact, a photography expert. The worst thing you can do is nothing.

My suggestion is that you blog about photography and not about your political or religious views. Blog about the things that are tied to why potential clients stopped by your site. I doubt very much that folks looking for a photographer stopped by your site to read about your political views. That has to be common sense.

Set up your blog to showcase your images as large as they can be shown on a standard screen. You are a photographer; showcase your images. At a minimum, try to blog once a week. It gives people a reason to come back. Consider writing about photography as it relates to the customer. Why is photography important? What makes for a great photographer? How should a person go about selecting a photographer?

If you're successful at becoming an expert, you'll find that you'll start to build a fan base that sees you as their first choice in photography, and they'll be more than willing to refer you to friends and family.

Facebook Advertising

Cost = Medium Time = Low Return = Low–High

This section discusses the advertising aspect of Facebook. The next chapter explores Facebook in more depth as a marketing tool. Facebook as an advertising medium is an interesting animal. It's where everyone seems to be today, but getting people to pay attention to your ads has been its Achilles heel. Don't take my word for it; take Wall Street's word for it. Since Facebook's stock went live, its price has been hammered because it's not generating the revenue it should be. And the main reason is because advertisers don't see the value in it.

My recommendation here is for you to check it out. They have a lot of great tools in their advertising admin panel. You can log in and drill down into your demographic. For example, you can find all the people in the United States who list "photography" in their profile as a hobby or interest. Currently, that number is over 4 million people!

Go try it out. See how many people have a family? Or are in high school? The numbers are staggering. You also have the ability to narrow it down by geography, zip code, and other factors.

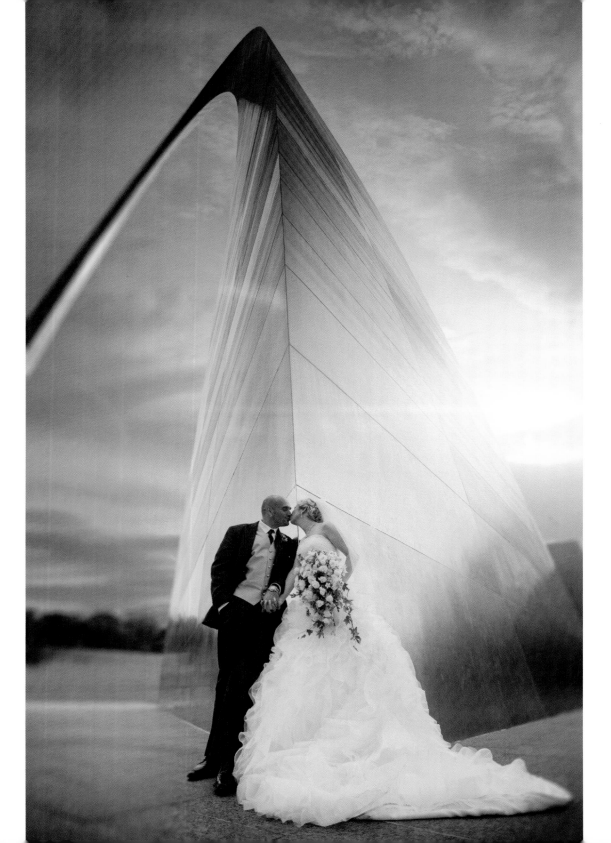

The key with anything like this is to give it a try and limit your potential losses. I'll spare you the how-to in this section since there's a plethora of how-to on Facebook's site. I've not had much success with Facebook advertising. Again, it's pretty inexpensive, so give it a try and see if it works for you.

Google AdWords

Cost = Medium Time = Low Return = Low–High

Don't confuse search engine optimization (SEO) with Google AdWords. These are two different things. We'll explore SEO and social media in the next section. From an advertising perspective, Google offers an option similar to that of Facebook.

AdWords offers you the ability to create an ad and choose keywords that are associated with that ad. Why are these keywords so important? Well, when a potential client searches for "wedding photography" you want to make sure your business comes up on the first or second page of results. I don't know many people—wait, actually, I don't know anyone—who goes past the second page of results. So, being on the main page is huge.

That's where AdWords comes into play. AdWords allows you to buy advertising space on the main page of search results with your preferred keywords. In this case, let's say those words are something like *cityname wedding photographer*.

Sure, you can get to the first page organically by setting up your site with SEO. However, when you first start your business, figuring out your keywords can be a daunting task. Once you determine the optimum keywords that you want your clients to use to be able to find you via search, getting to the main page of results is anything but simple. It could take years, if it ever happens at all. Companies spend six figures or more paying consultants and employees to strategize and implement all sorts of trickery to gain access to the top spot on a Google result page.

AdWords gives you the opportunity to gain access to that main page, but it comes at a price. Here's something most people don't think about as a strategy: how about using AdWords as a way of testing various keywords and their results? What you might think are valuable keywords might prove to be a flop. This is a great way to test your theory before investing all your time and energy in SEO.

Expertise: Writing for Others

Cost = Low Time = Medium Return = Medium–High

What better way to build your business than to establish yourself as the photography expert in your local community? And what easier way to do that than to write about it and get published? Writing about it gives you content for your blog and Facebook, and it also helps your SEO ranking.

What's your focus area? Start writing about it. Make sure you're completely unbiased in your approach to this. For example, let's say you're a family photographer. Write an article on the importance of a family portrait. Write an article on the top five things to consider when selecting a portrait photographer. Write an article on tips for selecting a wardrobe for your family portrait session to ensure the photos are timeless. These are just three ideas. Give it some thought, and I'm sure you'll come up with many ideas for short, concise articles.

From there, once you have your articles written, put them on your blog and on Facebook. Then reach out to local papers to see if they'll carry your story. Reach out to the blogs of related businesses. Businesses like clothing stores, toy stores, and so forth might be willing to run your article on their blog and website. All of this is contributing to you and your studio becoming recognized as an expert. This strategy will help you generate new leads for little to no cost.

Let's take a practical approach to our business and how we do this. We're wedding photographers. I think our clients would argue that we're one of the top wedding photographers in our area. To that point, I want to maintain my level of exposure for my business and brand. So, I reached out to a local wedding magazine and offered to write a column for them. I started writing about topics and concepts that I felt were applicable to today's bride; for example, "How Do You Select a Wedding Photographer?" or "Photography for Today's Bride."

These are just simple topics that, if written correctly, establish you as an expert in your field and local market.

Word of Mouth

Cost = Low Time = Low Return = High

This is the Holy Grail of marketing. It doesn't get better than this. If you can give your clients an experience they'll never forget, they'll tell everyone they know about it and the business will come in with little to no additional marketing on your behalf. Notice I didn't say "little to no effort." In order to get clients to talk about your business, you have to make a lot of investment in the client experience. That does take time and effort. But once that happens, getting new business via word of mouth is priceless. It truly is like winning the lottery.

Every time our phone rings or we get a new email via a referral, I get excited. It lets me know we're doing something right. Our clients are fanatical about our work and their experience with us. So, the real question is, how do we put a plan together that convinces our clients to talk about us? Well, that's just it—think of it as the non-plan. You can't force clients to talk about you or their experience. It's one of those things they either feel or they don't feel. And they won't do it if you prompt them to. It has to come from the heart.

Your motivation must emanate from the customer experience. If you're committed to continuous improvement in your company and committed to the customer experience, they'll talk and your referrals will come in with more frequency than you could ever imagine. Now, I don't want you to think that all you have to do is provide good customer service and that's it. It's good customer service combined with everything else we're talking about here that will lead to the overall success of your business. But you have to be absolutely committed to the customer experience.

The Plan

Don't overcomplicate it. Putting a plan together can be as simple as taking out a sheet of paper and writing down your goals and objectives. In fact, this plan should help your overall business plan. There's no sense in marketing in animal magazines if you're going after weddings in your business plan. So, move forward with that goal in mind: *The marketing plan must enhance and add value to the overall business plan.*

That being said, what should this plan look like? Get out a pad and paper, and start writing. At first, keep it simple and write down the date. Then, write down high-level goals for your company. This should come from the business plan. Yes, I want you to write this down again. For me, it helps me to continuously look at my goals and objectives to be sure that everything I do is working toward those overall goals. It's too easy to get sidetracked these days with cool new ideas that don't add value to the final goal.

Create a section and label it "Immediate Executables." Now that you're looking at your goals and objectives, what 3–5 options can you put into play immediately? Not next month, next quarter, or next year. These need to go into effect in the next 5–7 days.

Next, create a section and label it "3-Month Plan." Here, write the 3–5 tasks that might take a little longer to implement or cost more money.

Next, create a section and label it "6-12–Month Plan." Same concept here. Think of 3–5 things that might take a little more time, but still need to be documented in order to plan and execute them.

Let me give you some examples of each through my eyes.

Immediate Executables: Create a press release about some new product or service you're offering, like a 50 percent off session fee discount for all family sessions booked this month. Send this press release to every paper and social media outlet. It's easy and it's free.

3-Month Plan: New logo. More than likely, it's time for you to rebrand and create a logo that's worthy of being on everything that you put out there. However, it's going to cost you a little money to make it happen. In addition, how about making it a goal to get 500 Facebook fans? That's going to take time and will require a plan.

6-12–Month Plan: If you're a family photographer, establish relationships with local toy stores and convince them to display some point-of-sale material to promote the cutest baby contest. How will this work? Any family who participates gets a free 11x16 and the ability to purchase more pictures, but they'll be entered in an online contest (you betcha—on your Facebook site) where the winner will receive $1,000 in free pictures. (By the way, I just made this up and I am not going to lie...I like it! You better use it before I do.)

Next Steps ▶▶▶

Okay, so you just finished this chapter and you're amped up! Well, don't sit and wait, get to it! Start putting a marketing plan together. Even if it's just some rough concepts or ideas you want to investigate, do something. Don't wait.

Put a list together of the top five things you want to try and get to it.

Ultimately, your marketing plan is a living document, and it should be revisited every three months to make sure you're getting the ROI you'd hoped for and to redirect your efforts to changing market conditions.

And no matter what you do, never give up! Marketing works. It's what makes the world go 'round. The key is adjusting your plan to your business.

six

Getting Social

"GETTING SOCIAL" CAN be one of the most daunting tasks for any professional. The truth is, we live in a digital world that's always on. Clients are out there, online, and from the comfort of their own home they're searching for a photographer. When they stumble across your site, what will they see? Have you tied your branding and marketing plan together to ensure they have a killer experience? This is their first impression of your business and you don't even get to say hi.

We all need to understand the power of the Internet. It extends far beyond your website. Today's client is web savvy. They've grown up with a mouse in their hands. Rarely will a client pick up the phone to contact your business; the Internet will be their first stop, where they look to their peers for guidance and advice. They'll research your business late at night, gathering all the information they need to make a decision. What will they see?

In this chapter, we'll explore your options in the digital realm and put a strategy together for you to get up and running quickly and efficiently.

The Importance of the Web

It's all too easy to write off your website as just another "thing" to worry about. However, the truth is, I think it's the main "thing" to worry about. It all comes down to understanding consumer behavior. Today's consumers are completely different from their parents, and they behave completely differently, too. I think there's also a trend of anonymity that's begun, and which I believe we'll continue to see. People love to hide behind their email accounts and their monitors. It allows them to ask questions and do research never before imagined. This can be a good thing and a bad thing for any business. What will they find when they look up your business?

For our studio, in many cases the Web represents our first exposure to a client. They could be there looking at their friends' and family's pictures, or they could be searching for their wedding photographer. Whatever their reasons for stopping by, I want to ensure they're seeing our best.

This is where I see the biggest breakdown among my fellow photographers. I stop by your website and I see a hodgepodge of technology and information. Your website is much more than just a place where your potential new client can get information about your business. It's a place where they're judging your business. They're making decisions about your brand. When it comes to your web presence, don't underestimate the power of the brand. Sure, we all know a guy who does websites. But does this "guy" know anything about branding, usability, or search engine optimization (SEO)?

Today's consumer is bombarded with information from the biggest companies in the world. Those companies spend billions of dollars on branding

and marketing to ensure their websites match their overall brand and experience. So, as a photographer, what allows your brand to match up against the big players? Remember and think about your competition. Anyone can be a photographer. And anyone can slap a website together. All it takes is a few pictures and a website template for $9.99, and you're up and running.

We have to do everything in our power to stand out from the crowd. For years, I've been preaching about finding ways to do this. Well, a great website that successfully communicates your brand and shows your best work is a must-have for your business. It doesn't have to be overly flashy, but it definitely has to be easy to use, and it must stand out from the crowd.

Let's take a look at the keys to a powerful website.

Performance

One of the worst things that can happen when a new client comes to your site is that it takes forever to load! Patience is at its all-time low. People want instant access to information. Google even highlights how long it took for your search to come back...in milliseconds!

Make sure you spend a few extra dollars each month and host your website on a server that gets your main page up as quickly as possible. And speaking of the main page, keep it simple. The more information you place on your main page, the longer it will take to render for the end user. I've seen people just go to another site altogether because they got frustrated trying to navigate the site or waiting for it to load.

A data-heavy site means you're instantly adding information for the end user to download, which of course takes longer. However, I've found that consumers do have a *little* extra patience for great images to load. After all, that's why they came to your site. In the spirit of performance, you might want to visit your strategy for posting images.

How you size your images is directly related to performance and experience—not to mention the quality of your images. We use an export script from our photo-editing software. We size the images at 940 pixels on the long edge at 72dpi. That creates a decent-sized image that's great for our website and our other social media uses. Now, you might be thinking, why

so big? Of course, we can go smaller, but then we start to encroach on the user experience. We're photographers, after all. And I want clients to be able to see my imagery at a decent size, not tiny thumbnails. Think about it; I don't want to sell small prints. I want to sell large romantic images for their home. How can I do that if everything I show them is tiny? Go as big as performance will allow! But find that sweet spot; you don't want to be uploading the largest files your camera can create.

Think Mobile

You might be interested to know the percentage of mobile users hitting your site. Do you know? Have you ever checked? Do you know where to look? Well, if you have a website, you definitely need to take a look at Google Analytics for your site. It's free and it's something you can embed into your site to track all sorts of data.

What you'll find is that an ever-increasing number of users are hitting your site from mobile devices. That being the case, you have to ensure that your site can easily be viewed from these devices. Devices like iPhones and iPads are just a few of today's mobile device platforms. This is a trend that will continue to grow; we can't ignore it. (My 63-year-old mom has an iPhone!)

Test your site from a mobile device to get a sense of what your clients are going through to get to the information they're looking for. Now—though I don't do this—I've seen companies create a site specifically for mobile devices. Not a bad idea. Of course, there's going to be an additional cost to creating and maintaining a separate site, but if a majority of your clients are visiting your site from a mobile device, this might be worth the investment.

Finally, you might want to consider updating your site to support HTML5. We can't get into specifics here, but just know that if you're using Flash to display your images, then iPads and iPhones can't show that work. This could have devastating consequences when your potential clients come to your site. You want everyone to be able to view your portfolio.

Branding

I'm increasingly surprised by the number of people who don't quite understand that your website is your brand. In the consulting we provide to photographers, your website is one of the first places I stop by to do a little recon.

When I get there, how long does it take your site to load? Is there a consistent theme across your site and blog? Usually the answer is no. I can't stress this enough. Remember, your potential clients are being hammered with multimillion-dollar marketing and advertising campaigns every day. These campaigns are intricately tied to the look and feel of the site and the brand.

This is paramount to your success as a small business. You want your clients to feel as though they are in good hands, dealing with an established business—not a weekend warrior. That creates a huge strategic advantage for your business. Visit our site (www.salcincotta.com) and I'm sure you'll agree that it matches our brand and gives the client a solid experience.

One Click to Your Portfolio

Now that I'm on your site, how easy is it for me to find the information I'm looking for? Namely, your portfolio. Remember, you're a photographer, and your potential clients are there to see your imagery. They're usually looking for a photographer when they stop by. Are you the one for them? They'll be looking to your imagery to determine the answer to that question.

So why make it difficult for them to get to the answer? On our site, you can get to our portfolio with one click! That's huge! You have to make it easy for your potential clients to find what they're looking for. Anything less just gets in the way.

Your portfolio is what will get your potential clients to the next step of emailing or calling you. So, if they can't easily get to that portfolio, there's little to no chance they'll reach out to you.

Recently, I was working with a studio that's about four years old. And they were growing more and more frustrated at the lack of new business coming in from their website. So, I took a look at it. I was horrified! It took me no fewer than five clicks to get to their portfolio. And when I got there, I wasn't even sure what I was looking at. This is *not* the experience you want your clients to have. It's not an Easter egg hunt.

Spend a little time exploring your own site and think like a user. If that's too hard, try having a pizza party and let your friends just bang away at the site and see how long it's taking them to navigate around and find your portfolio. Ask for honest feedback. Let them know the purpose of this exercise is to make your website better and you're not looking for fluff; you want the truth! Was it hard to find my portfolio? Did it take too long to load? Were the images interesting and representative of a high-end brand? Based on what they saw on the website, would that lead them to reach out for more info? Put your own list of questions together. I promise you, it will be well worth it.

SEO

Search engine optimization. Ah, yes, let the geeks out! I kid. I kid. But not really. Let's dig in.

Sure, SEO has been relegated to the HTML nerds and seems like this elusive black magic for your website, but I assure you, it is getting easier and easier. This little three-letter acronym, if properly executed, can bring new business to your store front with little to no work.

Six months prior to this writing, we were on page 10 of Google's search results for "St Louis wedding photographer." Today, we are on page 1! That's

a huge game changer for us. We get 8–10 wedding requests per week, just from our SEO efforts. And the great thing is, it's not that tough to do.

I'll tackle SEO in detail later in this chapter. For the time being, just know that it's very important. And if you aren't actively doing anything for SEO, then your site is more than likely nowhere near the first page of Google results, and that's a problem.

Relevant and Timely Information

What are you placing on your site? When was the last time you updated it? This can be brutal for your business. Think about it. You go to a site looking for information on their products and you see the site hasn't been updated in the last five months. Also, when you get there, the information you're looking for isn't there.

I'm betting that when people come to my website they're looking for great imagery! After all, I'm a photographer. I'm not a food critic or a fashion designer. I understand this huge need to let clients see the personal side of us, but I gotta be honest here: no one cares! My clients aren't looking for a new best friend who eats Melba toast on the beach with their pet rock. They're looking for a great photographer. And I'm going to do everything in my power to showcase that to them. We shoot over 50 weddings per year. We must be doing something right on our website.

We try to update the site weekly. Within days of a wedding, we'll post images from that wedding as a teaser. Sure, some of this is intended for the bride and groom, but a lot of it is designed to attract potential new clients. When potential clients come to our site they see lots and lots of—you guessed it—pictures. This demonstrates two important things for the client: first, that we create great images; and second, that we're a busy studio that's in demand. Frequently updating your site with current pictures is a must.

Don't believe me? Use yourself and your friends as a test group. What's the next major purchase you're looking to make? Go to that company's website. What is the #1 thing you're looking for? What the owner did for breakfast? Some cute little quip about the meaning of life? No! You're looking for information about their product or service.

No Pricing

Do not—I repeat, do not—place pricing information on your website. You're not selling a car or a purse. You're selling something more than that. Remember, you're selling an experience. And a price list on your website is no experience. In fact, it encourages the wrong behavior from consumers.

Putting your pricing online immediately establishes your product or service as a commodity item. A commodity item is one where there's no discernible difference between you and the competition. If that statement is true, close this book right now; you're wasting your time. I'm teaching you how to build a luxury high-impact brand, one that consumers will lust for and pay top dollar for.

That said, I'm okay with placing your starting point online. Something along the lines of "Packages starting at $1,999" is a perfect way to ensure you're prequalifying clients before they email or call you. If someone reaches out to you after they've seen your starting price, they should be ready to go. The ultimate goal for you (and of your website) should be to get to the meeting with the client. This is where you'll shine, showcasing your products and services and what makes your studio so unique—all the things that can't be communicated in a bulleted price list on your website.

Impact Imagery

Another huge mistake I see photographers make is putting lame images in their portfolio. I hear things like, "But I like that one, it was fun," or "I don't have anything else to show." Just stop making excuses.

On our website, we showcase only the best images out of our studio. I show only images that I call "impact images." These are images that move our clients. Images that represent our brand. Images that represent the type of clients we're looking to work with.

I should not see schizophrenia when I get to your site. Within the first five images I should be moved by your work. Considering the average person spends less than two minutes on a website, you don't have a lot of time to wow them. Make every image count!

Why show pictures of shoes and jewelry? Are you a product photographer? Do you find your clients booking you because of the amazing shoe pictures you took at the wedding? I don't. Sure, I capture those images, but I don't see a need to place them in my portfolio. Instead, I show consistency in my images and my editing style. This ensures that I attract the right kind of clients. Love or hate my work, one thing is certain: When you go to my site, you'll see a consistent look and feel in my body of work. I'll never get a client who is looking for traditional photography. It's all but impossible.

Find your best images that represent your style and the type of client you're looking for, and get those in your portfolio online. Everything else...hit the Delete key!

SEO

Ah yes, back to search engine optimization. You thought you might have escaped all that gobbledygook. Unfortunately, we all have to get our little geek on here. However, I assure you, no programming is involved. And though entire books are dedicated to SEO, my only goal here is to give you a high-level understanding of why SEO is important to you and your business.

Search engine optimization. SEO. What does it mean in English? Basically, it's all the tasks involved in ensuring that your site is correctly set up and optimized for search engines to properly catalog your site. See, companies like Google, Bing, and Yahoo! send out these little search bots to your site and they "crawl" your site and its navigational structure looking for key-words—terms that best describe your content—to properly rank your site.

Let's take a look at the things you can do to get started thinking properly about your site and SEO.

It's All about the Text

Being in the imagery business, we sometimes forget that we need to add some copy, or text, to our site to describe what's on it. In fact, if we just add pictures, while our clients might love our visually appealing site, the search engines will hate it. When our site first went live, we were focused on the imagery; the problem with that was, we couldn't be found via any search engine.

Fast-forward six months later. We were extremely diligent about adding supporting text to our posts, and we're now showing up on the first page of Google results when someone is looking for a "st louis wedding photographer"—and that's our goal.

Try to steer clear of visual-only sites or templates. They look great but you need a way to add descriptive text to your site. You have to add lots of text to your site in order for it to rank highly. It's the age-old debate: design vs. function. Try to find balance, but in this case, my money is on function since I now get many inquiries from Google searches alone.

Keywords

Now that you're adding all this descriptive text to your site, it has to be tied to your keywords. Keywords are those major descriptors on your posts that are defined using H1 header tags (big and bold). These keywords tell your guests and the search engines what's on your page. And depending on the frequency of your keywords, this will indicate how relevant the content is as it relates to those keywords.

For example, since I want to be found for any searches of "st louis wedding photographer," I have to ensure that these words are prevalent throughout my posts. Spend some time thinking about how your clients will find your business. What will they search for so that they'll find you? If you don't know, ask them. Use the keywords that they give you and start building content that uses them. This strategy will give you the best chance of ranking.

Name Your Images

Believe it or not, how you name your images can have an impact as well. When you name your image "jones_123.jpg" or "dx1234.jpg," it's meaningless to the search engines, and you've lost an opportunity to be found online. Instead, add your keywords to those images.

For example, something like "stlouis_wedding_photographer_jones_123.jpg" is much better. It's little things like this that can make a big difference in your search engine ranking. I use a software program that automates the process for me when I'm exporting my images for my site. So, once you create your export process, this file-naming process is completely automated.

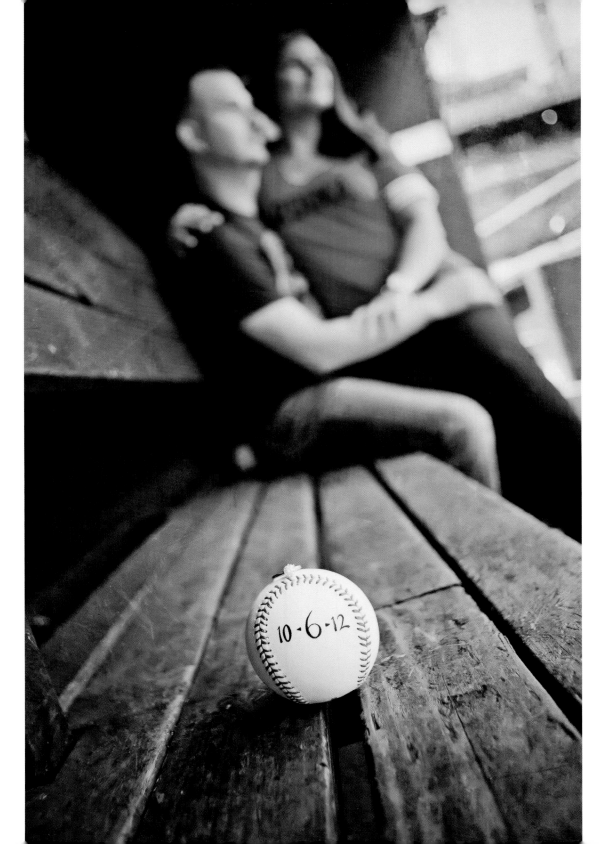

Inbound Links

The search engines have something called "trust rank." Now, you won't be able to find out a whole lot about this. It's like a best kept secret, but those who know SEO also know and understand what trust rank means to your site.

Here's how I want you to think about this. Let's say you're looking for a doctor. How do you find one? Typically, you'll ask your friends or family for a referral rather than looking in the yellow pages. You'd trust someone referred to you by a friend or family member before you'd trust someone you know nothing about by letting your fingers do the walking.

Well, the search engines work the same way. By accumulating some inbound links from sites that are already well ranked, in a sense they're vouching for you. They're referring you. Look for people in your respective niche that might be good candidates to do some link sharing. For example, if you're a wedding photographer, then connect with florists or dress shops. If you're a children's photographer, try connecting with toy stores or clothing stores. It can be as simple as them adding a preferred vendor page to their site and a link to your site. But make sure the link uses your keywords. For example, for me, the link would read "st louis wedding photographer" and clicking that link would take the user to our site.

Such links will immediately add credibility to your site and help you jump up in the rankings.

Easy-to-Use Tool

Now, remember I told you that you don't need to be a programmer to figure this all out? Well, I wasn't lying. There's a tool I use that I embed into my WordPress website. It's called Yoast. Check out Yoast.com. It's a free plug-in that gives me advice on tweaks I can make to my page so that it ranks higher.

Social Media

We've spent a significant amount of time discussing the benefits of getting your website in order. Well, today—more than ever before—our social media presence is as important as our websites.

And make no mistake. Today the major players are Facebook and Twitter, but there's no doubt the landscape will look much different in the next three years. With companies like Google and others trying to capture market share, one thing is for sure: Our clients are to be found in these social media areas.

Our job is to try to anticipate the trends and how they can impact our business by allowing us to stay connected with our client base.

That being said, today, we focus our efforts on three social media areas.

Facebook

Facebook is by far the most powerful tool in our social media arsenal. This is where your clients are. This is where their families are. This is where their friends are. And best of all, by using this platform, you're able to showcase your images for everyone to see. You can push imagery out to your current and potential clients instead of waiting for them to come to you.

So let's explore some ways to best use Facebook.

Do Not Use Your Personal Page

Using your personal page is a recipe for disaster. Keep your personal and professional lives separate. I don't want prospective clients coming to my personal page and seeing where I was on vacation or what I did last night with my friends in Vegas. It's just unprofessional. Now, I'm not saying we don't become friends with clients over time, but the bottom line is that I don't post to my business page any personal information, religious or political views, or anything that doesn't support my brand.

At the end of the day, Facebook is free. Create a business page and post all your images and business-related information there so the people who need and subscribe to this information can have easy access to it.

Separate Pages for Each Line of Business

Let's take it a step further. My wedding clients don't care about my senior portraits, and my senior clients don't care about my weddings. Sure, if they go to my website they can see it all, but from a social media perspective, I want to keep them separate—not only from a branding perspective, but from an ease-of-use perspective.

When it's wedding season, my Facebook page is loaded with recent images and weddings. I don't want my senior clients to have to dig through all that information to find what they're looking for, and vice versa. So I keep separate pages for each business, which gives me the ability to customize the banner on the page, as well as offer targeted specials to each group.

Post with Frequency

The worst thing you can do is be idle. Keep active on your site—and not with garbage posts about your favorite color or news stories. Post relevant information about your business. I don't care if you have to get out there and shoot for free. Build your portfolio—do something! Find some side projects to work on.

When I go to a website or blog and see static content, this, to me, is the first sign that I'm looking at a part-time photographer or one who is on the brink

of going out of business. This isn't the message you want to send to your clients. Ensure that you're staying active with posts at least once per week, if not more often.

Now, I know a lot of you'll be asking "Well, how often should I post?" I don't know. And it doesn't matter. Sure, there has been study after study highlighting when the perfect time of day is to post and what days are better than others.

Here's my philosophy: If you're reading this book and building your business, then you don't have time to worry about when the perfect alignment of the moon is to post your content. You know when I post? When I have time! That could be at 2 a.m.. Focus on the things that matter. For me, spending the effort to post frequently is more important than worrying about posting at exactly the "right time."

Do Not Friend Request Your Clients

Oh boy, this should be common sense, but all too often it's not. Do not be that creep asking to be everyone's friend. If your clients want to be your friend, that's up to you. I have my personal opinion on that—and my wife has her own. I don't post anything on my personal page that's going to offend anyone, so I'll friend just about anyone.

My wife, on the other hand, will not friend you unless she has had a drink with you. Hard to argue with that logic.

However, nothing is worse than sending your clients a friend request. They're hiring you as a professional to work for them. They aren't hiring you as a personal friend. Let them make the call and reach out to you. Trust me, it's better that way.

Twitter

Honestly, I find Twitter to be best used from a professional perspective. My clients aren't big Twitter users, and the truth is that it's not the best platform to showcase your images.

This is where you might find me tweeting more personal information since that is what it's geared toward. Most of my followers on Twitter are other professional photographers. Very few are actual clients.

Obviously, there are many people who have become Internet superstars using Twitter as a platform. I encourage you to think about how you'll use Twitter to promote your business.

For our studio, there are only so many hours in the day. Twitter provides the least amount of returns to our business, so I tend not to spend too much time there.

Plug-ins are available that will allow your Facebook posts to automatically publish to your Twitter account. This is probably the best of both worlds; it puts the same message out and reduces the amount of work for you.

Blog

I love my blog! It's totally integrated into our site and perfectly set up for SEO, which, as it happens, are two things that Facebook can't do for you. It can't provide you with any SEO for your site, nor can it be customized to match your site. And though I love my blog, there are certain things my blog can't do that Facebook can. The biggest advantage of Facebook over my blog is, as discussed earlier, the push versus pull concept.

The only way people will see what you posted on your blog is if they come to your site every day, which is something no one will do. But on Facebook, information is pushed out to people in their newsfeed. So, they automatically see your posts.

As I've already mentioned, there's no way to truly customize or brand your Facebook site to integrate into your website. Ultimately, there are pros and cons to each, and that's why you should do them both.

With that being said, let's explore how to get the most out of your blog.

Post with Frequency

This is the same as my Facebook advice. You have to institute the same policies on your blog. In fact, the same content that you're posting to your Facebook site should be posted to your blog. Don't make it complicated. We post the same images to both platforms; however, as you'll see in a moment, we expand on those posts for the blog by adding text, highlighting the event, and using SEO keywords.

Drive Traffic Back to Your Site When You Can

Try this: Take the link from your blog post and enter it into your status on your Facebook page. You'll see it automatically pulls your blog information into Facebook—a very powerful feature if used correctly. See, when people click on your Facebook post, it will take them right back to your website.

This is important for keeping people on your site and controlling the experience. You want all potential clients to see not only the images they want to see, but to be able to get more information about working with you and learn about other services you offer.

Keep It Professional

I know, I sound like a broken record. Unfortunately, I've seen blogs turn unprofessional over and over again. Think like a business, not like an artist. As a business, give clients what they're looking for—information about your business. And in our case, it's pictures, pictures, and more pictures.

Talk about the event and what made it special. That's a great way to showcase your personal touch, your caring side for the clients and the moments in their lives.

But when things slow down, it's better to be working on your portfolio or your "image of the month" or "favorite images of the year" rather than talking about your life. It's not a diary. It's a business tool.

Keep It Visual

The more images, the better! After all, that's why potential clients are there. Show them what they came for. There are all sorts of programs available that make it easy for you to export and create images with your logo on them that are properly sized. As I mentioned earlier, we export at 940 pixels on the long edge and 72dpi. It's perfect for the Web and lets everyone see the images at a decent size on their screen, phones, and tablets.

Think SEO

Don't just post the images. This won't help you rank higher. This is a perfect opportunity for you to write something about your clients. Not only does it add your personal touch to the event, but it creates a huge opportunity for you to rank higher as well.

If you're a wedding photographer, how about this for an idea? When you get a new client, before you post to the blog, give the couple a questionnaire to fill out about how they met, what they love about each other, and similar questions. Encourage them to tell their story, whatever it is. Then use that as the basis for the post. This creates a great editorial for your site and one that potential new clients will enjoy reading along with looking at those great supporting images.

I hope this chapter has been helpful for you. A lot of the things highlighted here can easily be introduced into your business in relatively no time at all, and with little to no expense. As far as I'm concerned, those are the best kinds of changes to make. Get out there, make these changes, and you'll notice an uptick in your inquiries and bookings!

Next Steps ▶▶▶

This is an overwhelming chapter, I know. If you've been resistant to engaging in social media, your head is probably spinning right now. First, take a deep breath. Relax. Tell yourself it's going to be okay. If you're a seasoned pro, hopefully I've given you one or two new things to think about.

Develop a 30-day plan on how you're going to put a consistent social media strategy in place. There are a lot of potential changes that will have to be made to your business and strategy if you're going to be successful. I can tell you, though, that if you put the energy into this plan, it will be worth the effort.

When we post something to our social media sites, we get a lot of client response and interaction. This has happened through years of effort and by training our clients to engage with us through online channels. You can do it, too.

seven

Costs and Pricing

OKAY, SO NOW you're out there. Your marketing, branding, and web presence are firing on all cylinders...and now the phone rings. Holy cow, what do you do? How much do you charge? Understanding your costs will help you determine your price. Too many people jump into business without a full grasp of the basic concepts. In this chapter we'll drill into the business basics to get your costs under control and put a pricing structure in place to ensure you make a profit and earn a good living.

Costs

Costs. Sounds easy enough: This is how much I paid for something, right? *No!* That's not how it works. I love when I'm talking to people who got into this industry as a hobby, and they insist they are making $50 per hour. "What do you mean, Sal? I shot a wedding over the weekend for 10 hours. They paid me $500 and all I had to do was burn a DVD for them. So, my cost was like $1, right?" Good grief!

Trust me. It cost a hell of a lot more than the price of the DVD. This is where the rubber meets the road, so to speak, and you have to start thinking like a business person—not like an artist. You have bills to pay, and you need to consider the cost of new equipment, insurance, retirement, and a host of other bills that add to your cost of doing business.

If you're reading this and you're one of those weekend warriors, I might seem a little harsh. But I am not harsh because I have ill will toward you as an enthusiast. I am harsh because I have no tolerance for bad business. You're leaving money on the table. Money you can use to buy better equipment. Money you can use to send your kids to college. Money you can use for...fill in the blank here.

See, I am a huge believer in our industry and a huge believer in empowerment! I want to see everyone find their own success, but sometimes I see people get in their own way and hinder their ability to achieve success. And with that goal in mind, let's start talking about costs.

Now, I don't want to go all business school on you, so let's focus on the things that will matter at a higher level and the things that will allow you to take immediate action within your business.

Cost of Goods Sold (COGS)

Often referred to as COGS, this number is important in your overall pricing strategy. Mistakes I have seen other photographers make are along the lines of pricing their work compared to what other photographers charge. Who cares what other photographers charge! Not a question. It's a statement. It just doesn't matter. You need to understand *your* costs and *your* clients before you can determine the price you're going to charge.

So, back to COGS.

The cost of goods sold is defined as something like this: "all costs of purchase, costs of conversion, and other costs incurred in bringing the inventories to their present location and condition. Costs of goods made by the business include material, labor, and allocated overhead."

English, please.

Okay. The costs for your business or products have to include the cost of everything that went into producing it along with some estimated costs for overhead. For example, the cost of an 8x10 print is not $2, the price you'd pay from a professional lab. In order to correctly determine the cost of that 8x10, we have to think about the following:

- Rent for our studio space (or home-based business)
- Electricity
- Shipping
- Gas
- Drive time to and from shoot
- Storage space for the digital images and their archives
- Insurance
- Administrative overhead like phone calls, packaging, inspection of the prints, customer service
- Equipment like computers, cameras, lenses, memory cards, flashes
- Continuing education

And the list goes on and on. I guarantee you one thing: This costs a lot more than $2. In fact, if you're charging less than about $25 for an 8x10, you're probably losing money on the deal.

Here's where I see a lot of photographers—and business people in general—go wrong. They completely underestimate the cost of their business operations.

Although I know some of these costs seem insignificant, they add up quickly. These are costs that can't be ignored and have to be accounted for somewhere to ensure that you're successful in both the short and the long term.

What a lot of other kinds of businesses will do is come up with a magic formula given to them by the bookkeeping department to account for some of those fixed and variable costs to apply to the actual costs of the products.

This allows a fair gauge of what it's actually costing you. Of course, some of these numbers are a little magical. For example, let's take gas: You might drive 5 miles to one client and 20 miles to another. I don't expect you to sit there and calculate your actual costs every time you have a photo shoot. You'd be spending more time tracking your costs than you'd be actually shooting and making money.

The big thing here is to understand that these are actual costs that can't be ignored. If I can get you to see that, we're heading in the right direction.

That being said, my formula for costing goes against the grain a little. Let me explain. I don't want to spend time trying to track my costs or time down to the minute, but I still need to be profitable. So I use a costing formula of 15 percent. Simply stated, if I can keep my cost of hard products at 15 percent, the rest will work itself out.

Now this is a rough number and you have to understand my sales process. We don't sell a la carte. We are a package-based studio. (Later, we'll talk more about why I don't believe in a la carte pricing or build-your-own packages.) The 15 percent figure does not hold true for individual prints. So, an 8x10 will cost you about $2. With the 15 percent number, you would charge $14 for an 8x10. You would also go bankrupt.

I am also not a fan of the pricing calculators that encourage you to add a markup of 300 percent (or any other variable). They don't work quite right either. Let's follow our 8x10 model: $2 cost x 300 percent markup. Now you're charging $6 for an 8x10. Oh boy. I can see you earning that starving-artist badge quickly.

In all seriousness, though, there's no foolproof method for pricing. There are two lessons to be learned here. One, there's no silver bullet. You have to massage this process to fit your business and each individual product you offer. Two, a la carte pricing makes it difficult to achieve any sort of consistency. Instead, I believe in a bundled-pricing strategy. This gives you more control over your overall costs and profits. And frankly, your clients are already used to bundles. Everywhere they go, things are bundled for discounts. From the grocery store to Sam's Club, bundles are the way to go.

Pricing

No matter where I go or who I talk to, how to price your goods or services seems to be the biggest challenge for any photography studio. But pricing strategy doesn't have to be complicated; it just needs to follow some basic business principles. And now that you have a good idea of the cost of your products and services, you should be able to price for success.

First, let's explore a few questions out there. Should you offer a la carte pricing—basically allowing clients to build their own packages—should you offer a print credit system, or should you offer a bundled system? These are all reasonable questions you may have. The biggest problem of all: there are educators all over the country teaching different philosophies. Ultimately, you'll have to come to your own conclusion based on the type of business you're running and what you think will work best for you.

The Session Fee

For me, the session fee should be for just that: the cost of the actual session. The client is paying for your time and talent as an artist. Don't throw everything and the kitchen sink in there. You're devaluing your offering if you do that. If people want to work with a professional photographer, there's a cost associated with that. Granted, a session fee is going to be associated with more of the portrait-style photographer. However, the point is still relevant. You have to figure out how to charge for your time.

The amount you charge is dependent on many factors, including your niche, your experience, and the current competitive landscape. No matter the kind of photography business you're pursuing, you need to calculate this fee.

Our studio charges about $300 for most portrait sessions. This includes a certain amount of time for the actual shoot. No prints or digital files are included in this fee. All those items are listed earlier and beyond the cost of my time. When we were starting off, we charged about $100 for a session. I think that's a great place to start. Having a fee for your time will ensure you get closer to working with the right clients—those who appreciate the value of your service.

In the spirit of talking about the value of a session fee, the next logical question should be "Would you ever waive your session fee?" Absolutely. As with everything else in the world and your business, you need to look at this stuff on a case-by-case basis. When it makes sense, I will waive my fee knowing that there's a bigger sale and opportunity on the back end of the shoot.

Look within your industry to get a sense of how much photographers are charging for their services, but remember: This is just to get a sense of the market and should be used for reference only.

Various Pricing Models

As I previously mentioned, I am a package/bundle guy. You'll see that I err on the side of bundled discounts in all my offerings, and I think our clients are used to this. It's basic consumer behavior—people want a deal. Let's explore each option.

A La Carte

This allows your client to buy whatever they want and build their own custom packages. Sounds like a great idea at first. I mean, what's not to like? I can see the promotion behind it now. "We allow all our clients to build their own custom packages." However, after some implementation you might soon realize you're limiting your sales. Why, you might ask?

When a client is selecting and building their own packages, they are making pricing decisions—the worst kind of decisions for our type of work. They are adding things up in their head and seeing how much things are starting to cost. This will influence their behavior in the wrong way. Rather than selecting what they want, they end up selecting what they can afford. And the more they add to their shopping cart, the more those dollars add up. In my opinion, this sales model is not conducive to consistently big sales, and I base it solely on my own behavior as a consumer.

Credits

A credit-based system can work a number of ways, but the most common might be along these lines: purchase this package or session fee for $X and get a $500 print credit for our studio.

This is the worst model of them all, no matter how you cut it. When you sell a client "credits," their mind-set is in the wrong place. I know this, because we tried it.

No matter how they acquired the credits, the end result is the same. The client believes they don't need to spend any more money because, after all, they have all these amazing credits.

Again, it comes back to consumer behavior. Ask yourself this: When you have a $100 gift card to your favorite store, do you go in planning to spend $500? I know I don't. Which is not to say I won't spend more, but it's an uphill battle to get me there. I don't want to arm wrestle with my clients to get them to spend more.

When we implemented this model, client after client would walk in thinking they didn't have to or, worse yet, didn't want to spend more money. Then we had to become heavy-handed with the sales tactics to get them to spend more, and that is not who I want to be. I want to be able to look myself in the mirror every day and feel good about what I am offering clients. I don't want to feel like I'm an infomercial host.

Packages

If you haven't already been able to figure it out, bundling is my favorite option. Why? At its core, everyone loves a deal! Bundling is everywhere we look. *Everywhere!* From fast food to home purchases, there's a bundling of products or services that will, compared to buying things a la carte, save you money as a consumer.

From a seller's perspective, bundling helps you get larger sales averages because you are, to a certain extent, directing clients to larger bundles that offer them great savings and, hopefully, more profitability for you and your business.

So, let's come back to consumer behavior. Whereas a la carte pricing gets a client thinking about how much something will cost them because they see the number growing with every item that they add to their list, prepackaged bundles evoke a model of cost savings. Clients see that by buying into a bundle they are in fact saving 30, 40, 50 percent, or more. The psychology here is brilliant. Marketers all over the world employ this model with great success. Who am I to argue with them?

This model drives sales based on an approach of savings rather than spending. It's as simple as that, and it works. It works on me, works on you, works on consumers everywhere, because it makes sense.

The Psychology of Pricing

Here's what you should *not* do when trying to determine your pricing: look to your competitors. This is one of the biggest mistakes I see photographers around the world make. We offer a unique, one-of-a-kind service; I don't care what Bob down the street offers or charges.

You have to value your brand. You have to value the service you provide. Playing copycat isn't going to help you find success. You have to find your own niche. And pricing is a big part of sending a message to clients on where you stand as a business.

Are you competing on price or are you competing on some other factor, such as service and quality products? There are certain industries in which competing on price is the way to go. The low-cost provider wins. This works

well for products that are commodity products/services. Commodity products/services are those products/services that have no discernible difference between them. Toilet paper is one of those products. Is your artwork the toilet paper of your local market? I sure hope not. I see my artwork as being extremely unique. And as a unique product offering, I can charge a premium for that. I will not compete on price.

Here's something I can guarantee you. If you compete on price you'll ultimately fail! You're a limited resource. You can only work so many events per day, edit so many pictures, take so many phone calls. Look to the corporate world for proof of this. Show me anywhere in the corporate world—any product, any service—where a limited resource is being sold for a discounted amount. Or where a company like that competes on price. It doesn't exist! You know why? Because it's a ridiculous way to run a business. So, stop it now!

You're more than a weekend warrior. You're more than just a DVD of images. You're more than just a guy/gal with a camera. You're an artist! People will pay you for your vision of the world. This is a gift. Value that gift and you'll have the confidence to charge what you're worth. Like anything in life, your product or service is worth whatever someone is willing to pay for it. I think there are a lot of people in the world who see the value of great photography and are willing to pay that premium.

Are you wondering how you get to the point where you're priced correctly? Well, there's no simple answer to this. It happens over time. You have to experiment with pricing. Raise it and see what happens. You might be pleasantly surprised. We kept raising our prices every three months until we found a place where we were happy with our income level and our clients were still willing to pay for our services.

The Value of the Brand

Now, let's take a quick look at these two options and how they create perceived value for your brand.

If you're the low-cost provider, you're in essence providing a commodity product. Through price alone, you're signaling that your product or service is not valuable. That's the wrong message to send any prospective client. You're devaluing your own business, and you don't even realize it.

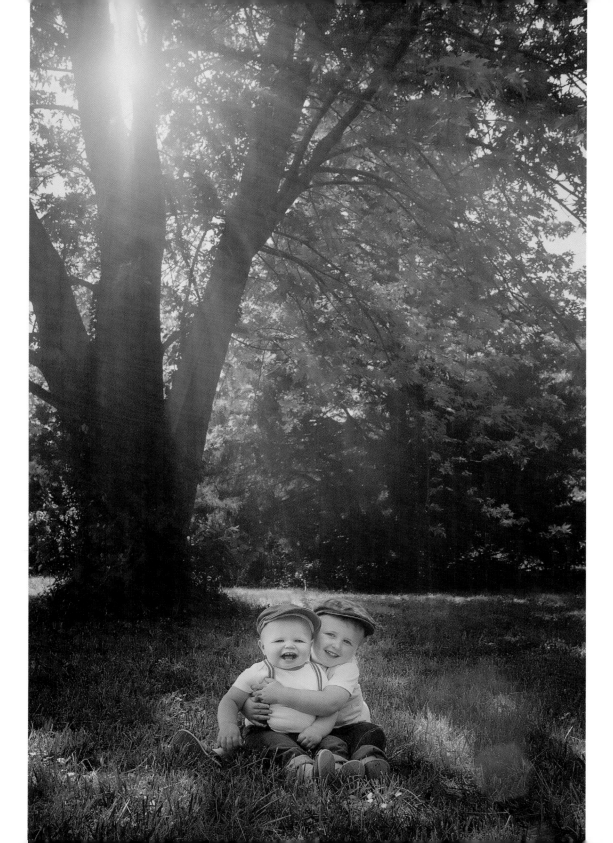

I run into photographers every day who tell me that their clients don't value them, their clients don't want artwork in their homes, their clients don't this or that. That's because the photographer is attracting the wrong kind of clients. These are clients making price decisions. They don't care about your artwork; all they care about is getting the best possible price. Once that happens to your business, you're screwed. It will be an uphill battle the rest of your career. Bad clients refer more bad clients.

The common misperception here is that if you raise your prices you won't book any business. That is 100 percent false. The complete opposite will happen to you. If you raise your prices, you'll stop booking bad clients. Not only will you continue to book business, you'll begin to book the right clients as well.

Pricing is an amazing thing. Charge more and consumers automatically make certain assumptions about your brand. It has to be better if it costs more, right? Now, I'm not suggesting that you go off and just raise your prices without offering a better product or service for your clients. This approach will undoubtedly lead you down the wrong path. It's a simple exercise to understand consumer perceptions and how they impact buying behavior.

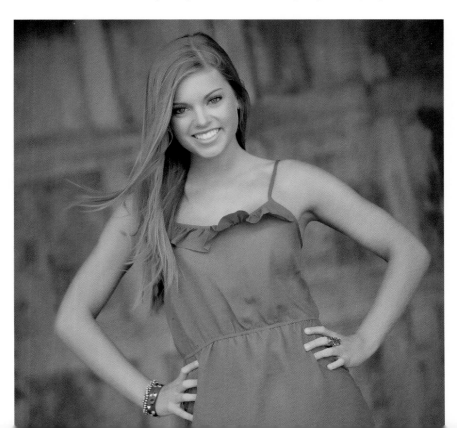

If your ultimate goal is to build a luxury brand, one that clients lust for, you have to charge the right price for that. And that's never going to be inexpensive. In our local market, we're one of the most expensive studios in the area and our business has exploded ever since we started raising prices.

We started to attract better clients. Not only ones who could afford us, but ones who couldn't afford us either. "Whoa, wait, Sal, you're telling me you're booking clients who can't afford you?" That's right! Think about it. We all know people who can barely make ends meet but have a 60-inch flat screen TV. Where did that money come from? It's simple. Everyone has money for what they want to have money for. It's about priorities.

My client is a client who sees the value in great artwork for their home. That client is willing to make sacrifices to get that great artwork. Why? Because they see the value in what we're offering—and because of our price point, they understand we're a limited resource and not everyone can afford us. That immediately leads to huge perceived value of our brand. I don't have to force people to spend money with us; they want to spend money with us to get access to this amazing limited resource: my time and artistic talent!

Establishing Value

This is no easy task. How you establish value for your clients can make the difference between being seen as an expert in your area or being seen as just another shoot-and-burner. What are you offering beyond the click? That's the question that has to be answered.

Everyone is a photographer today. We all know a friend or family member who has a camera and can do the family pictures or wedding pictures for next to free. How can you compete with that? For most photographers, they try to compete on price. Well, after reading the previous section, hopefully I have drilled into your head that's the worst possible way to compete.

Instead, we compete on value. We want to offer our clients as much value for the dollar as possible. We do this by offering high-end products and services. Something not found with that friend or family member—and definitely something not offered by the $500 photographer.

Service

I can't stress this point enough: Without service you have nothing. This has to be the cornerstone of your business model. Take care of your customers, and they will talk about you for years to come! Everything you do has to focus around the customer and the best possible service you can offer.

Susie Photographer can't offer service because she charges $500 for pictures and hands over the DVD. She can't afford to offer service. That cousin who has a camera and did the family pictures can't afford to offer good service either. After all, they are a family member, not a business owner. They don't care about service. They did this for free.

So where does service begin and end? Great service starts when that initial email comes in, and it ends when the final product is placed in the client's hands. Arguably, service should continue for years to come, but I'll save that conversation for another day.

How long does it take you to respond to client emails or phone calls when they come in? Too long, as far as I am concerned. We respond to 90 percent of client emails in less than 12 hours. Sure, there's occasions when you need to do a little research before getting back to the client. So, what's wrong with letting them know you got their email and will get back to them as soon as you can research their request? The worst thing you can do is nothing. Lack of communication is the worst possible thing you can do for your customers. It will always lead to frustration and misunderstanding.

How long are you making clients wait to see their images? If you're not showcasing their images in two weeks or less, you're once again providing bad service. People don't want to wait two months or more to see their images. They are excited. They hired you for great images and you're having them wait 6, 8, 12 weeks to see them? The excitement has worn off. More than likely, they won't spend money either. And what about that referral? Good luck with that.

You have to provide exceptional service in both a tangible and intangible way. The one thing to understand: This is a journey, not a destination. Every year we're looking for new and better ways to improve the customer experience. For example, whenever one of our clients books our top wedding

package we send them a bottle of our favorite wine and a handwritten thank-you note. That's a level of service that our competitors can't even begin to offer, and it blows our clients away every time. After every wedding, we send our clients another handwritten note thanking them for letting us be a part of their big day.

Service doesn't have to cost money. It just requires thought and effort.

Products

I hope your takeaway from all this isn't this: "Hey, Sal said raise prices and I will book more business." No, that's not what I am saying at all. Take my statement in context. You have to take care of all the other housekeeping items as well.

One of those items is unequivocally going to be your product offering. We don't offer to shoot and burn in our studio. I find it to be an incomplete service to our clients. I want to deliver high-end products to our clients that they will enjoy for years and generations to come.

When you're charging next to nothing for your services, you don't have the ability to offer your clients high-end products. This is case number one for raising your prices.

What type of products do we offer our clients? The number one item we offer to our clients are unique albums—not only in their design, but in their quality and leather options. Regardless of the type of client—wedding, family, baby, senior—they all lust after these high-quality products. It allows us to charge a premium for our services. Think about it. What client doesn't want an heirloom-quality product for their family to enjoy for generations to come? All of our clients love knowing they have an option beyond the DVD to display all their amazing images.

Just so we are in sync, know that this concept holds true no matter what industry or niche you're focused on. If it's not albums, then what is it? What products can you offer your clients that get them excited to work with you and allow you to stand out from the crowd? For our studio, we are on a never-ending search for those products. We go to trade shows every year looking for that new product we can add to our offerings to stand out in an ever increasingly competitive market.

Offering your clients a DVD is almost a joke to me. What are they going to do with it? Most have no clue. They just feel like they need it. Instead, show them what to do with it. Show them what you think is the best way to display their images. After all, you're the expert, right? Taking this extra step helps establish your value even more.

Packaging

How are you delivering the products to your clients? Our studio packages everything we have in a very professional way. We don't deliver them in a loose box. I want my clients to feel as if they just got the best gift in the world.

The way you package your products says a lot about what's inside the box. Do you value your products? Then show the client this. Show them from the minute you deliver it to them.

Nothing goes out of our studio that is unbranded! Everything. Every package. Every DVD. Every bag. It all has our logo and coloring on display. It's the final piece in your overall customer experience with your studio. Make it count.

A common quote from our clients is something along the lines of, "Oh my gosh, I don't even want to open it. It's just like a gift." Yes. Yes, it is. And that's exactly the response I am hoping to evoke from my clients. In return, they are extremely protective of their albums and prints because I am signaling to them that this is precious cargo.

And I don't want you to think it has to be expensive. First, make sure your branding is in order. Then, look for suppliers that can provide you with kraft paper that matches your look and feel. Pick up some ribbon that matches. Get some bags made. All these things are super inexpensive. Maybe it costs us $10 per order on packaging. If you're charging correctly for your work, this should be a nonissue and it will blow your clients away.

Creativity

Your creativity has to be part of your X-factor. This is where you have the ability to shine above the rest. Show that you're an expert. Show that your work is different from that of your competition.

For us, this is one of the easiest ways I've found to separate ourselves from the competition. We try every week to do something new, something different. I want to get people talking about our work. I want to provoke thought and conversation. That's my goal as an artist.

You might be wondering how to do this. For me, I read, read, and read more. I love to flip through magazines and read about new lighting techniques and trends. It gives me inspiration. I then use that inspiration to try new things with my clients. And in return, clients are constantly blown away by our level of creativity.

The same holds true with our product lines. We're always looking for new and innovative products to offer our clients. They see that as another level of creativity. We show them new ways to display and enjoy their images.

You have to find a way to push the limits for yourself as an artist. If not, you'll get stale, and your work will look like every other photographer out there. Find someone who inspires you and study their work. Study the lighting and the posing. Study the composition. And then find ways to incorporate those inspirations into your next photo shoot.

Experience

When all the dust settles, it's all about the experience the client has with you, and as you know, this is all tied to everything you have done with them from that first email until the final product is delivered.

That being said, what can you do to create a better customer experience? You must challenge yourself and your studio to raise the bar. It's this experience that will establish value for your brand in your local market—in any market.

Our clients tell us all the time, "You were worth every penny." That's an amazing feeling for us. That's how we want our clients to feel. If they feel that way, they'll spread the word and become our best marketing brochure. You can't buy that kind of publicity.

I firmly believe that we offer a high-quality product and service. However, I think the number one key to our success is giving our clients an experience of a lifetime. It's that experience that creates huge perceived value and allows us to be more than just "another photographer."

Next Steps ▶▶▶

What will you do tomorrow to change the client experience and offer a service that is second to none? I want you to think of two things right now that you can do starting tomorrow. Write them down right here, and then go execute them immediately! Here are two things I think any studio probably has room for improvement on: 1) returning emails or phone calls quicker, and 2) getting clients their images faster. Make those two changes and I promise you, your business will immediately stand out from the crowd as a top-notch photography studio.

In addition, get your pricing sheet out. Make sure everything you offer is listed there. Now, I want you to write next to every single item you sell the hard cost of that good, including shipping, tax, and similar factors. What does it cost you at the absolute minimum to get that product to your studio? You should always have this information handy for reference. I know, within a few clicks on my computer, how much a product or package is costing me to fulfill for my clients.

And finally, sit down and start mapping out what you want the client experience to look and feel like within your studio. A great exercise is to pick a brand you truly admire and go through their experience. For us, we use Louis Vuitton as a model for our business. We went into the store, made a purchase, and enjoyed the client experience. From there, we took away many valuable lessons and ideas that we have quickly incorporated into our business. One example we incorporated: They offer their customers champagne or cappuccino when they are in the store.

Contracts

SURE, I KNOW: You're not a lawyer, but you play one on TV. Come on, we have been on the up and up until this point; you have all your plans together and you're ready to tackle the world, but you're about to get blindsided if you don't protect yourself and your business. Understanding contracts is a necessary evil. No matter what type of photographer you are—including a weekend warrior—contracts are part of the world we live in. In this chapter, we'll explore some basic contracts and model releases to understand what they are and how they'll impact your business.

I am not an attorney, but I can at least guide you on the things that you should care about when putting together your legal strategy. And make no mistake—you need a legal strategy. In this day and age, anyone can sue anyone for any reason they see fit. That doesn't mean they'll win, but they can make your life miserable. You owe it to your family, your employees, and your future to protect yourself as best you can.

After you read this chapter, I think you'll have a sense of where you're safe and where you're exposed. If you think you have any legal exposure whatsoever, meet with an attorney and put together a plan of attack immediately.

Protecting Your Personal Assets

If you're out there without being a true business entity, you're playing Russian roulette with your business. It's only a matter of time before someone comes along and sues you for something. Remember, we're in an increasingly litigious society.

Ask yourself this: Can someone trip over your bag? Can you lose a memory card from a wedding? Can you miss a key moment at an event? If you answered yes to any of these, and you're not a formalized business entity—that is, an S-corp or LLC—you have some serious personal exposure.

Let's explore a scenario. Wedding coverage. First kiss missed.

It doesn't matter how or why it happened, but it did. For whatever reason, you missed the first kiss. Without a doubt, the bride is upset and she wants to take it out on you. She decides that you ruined her entire day, and because of that, she is suing you for the entire cost of the wedding. You get served a summons for a $50,000–100,000 lawsuit.

Sound farfetched? Think it can't happen? Think again. It already has. This has happened many times across the United States, and the bride is perfectly within her rights to sue.

Here is the problem. If you're a sole proprietor, you could be on the hook for this both on a business level and a personal level. Translation: You could be sued for your personal assets—home, car, retirement, everything. Not only that, they can go after you for future earnings. So, if you can't afford to pay, they can render a judgment against you for future earnings until you're paid off. You do not want the stress of that on your shoulders. You have to protect your family, your employees, and your business.

Get Legal

It's time to get serious about your business. It's time to incorporate. We can't go through every single type of business entity in this section—see Chapter 2, "Let's Talk Business"—but it should go without saying that you need to meet with an attorney. Most business entities can be set up for about $1000 or less. Trust me, it's worth every single penny for the peace of mind.

For the sake of this conversation, you're an S-Corp. This gives you the tax advantages of being a sole proprietor and the legal protection of being a true corporation. You can't be sued on an individual level for missing a first kiss. So, you can rest assured that your personal assets are protected even if you were to have this unfortunate accident.

Meeting with an attorney will help flush out a lot of questions you have. Do not buy one of those online incorporation documents. You'll regret it soon enough.

Let me talk about a real-life scenario. There's a wedding photographer in Seattle who is currently being sued for $300,000 because the suit alleges that he provided inferior service that has caused pain and suffering and a lifetime of lost memories. As of this writing, the case is still pending. The problem here is the photographer is personally exposed. I'm not sure if he will win or lose, but it doesn't matter. The stress he must be feeling knowing that he could be done forever and be paying that $300,000 off for the rest of his life has got to be one of the most traumatic events in this man's life. My heart truly goes out to him.

Wedding Contract Basics

Even if you're set up correctly as a business entity, that's not going to prevent someone from bringing a lawsuit against your business. So, how do you protect your business? What should be included as part of the wedding contract?

What Not to Include

Here's what *not* to include as part of the wedding contract:

Meals or any other diva-like request. Get a hold of yourself. You're a photographer, not a Top 10 Grammy-winning artist. No, you're not entitled to a hot meal, even if you have worked all day. Holy cow. Are you kidding me? What job in corporate America have you ever held where you were entitled to and paid to eat? No job I ever worked at. When I was in corporate, they paid me to work, not eat. My boss told me to take a lunch break when I had time, and 90 percent of the time I ate at my desk while I worked. Bring a snack bar and suck it up.

We do not have this in our contract. We pack a cooler with us with water and snacks. And the vast majority of the time, either the bride or groom is gracious enough to either get us a meal or the venue will provide a boxed meal. If not, I could stand to lose a pound or two anyway.

Breaks. No. You do not get a break. What, do you work for the photographers' union or something? Last I checked there was no Jimmy Hoffa of the photography industry. Work, and do what the bride and groom have paid you to do. Rest on Sunday. Saturday is meant for ass-kicking! It's game day and you're the quarterback.

What to Include

Contracts are made to highlight deliverables and any other stipulations around the event. Think about a contract as "terms and agreements." You agree to perform this task and they agree to pay you this amount. What happens when someone doesn't deliver? This is called a breach of contract. When in breach, what happens next? All of this should be highlighted in the contract.

Key Concepts

Here are some key concepts to keep in mind:

Payment terms. How much are they paying you and when it is due? What are the terms of payment? What happens when they don't pay? These are concepts you want to flesh out.

For us, final payments are due 30 days prior to the event. In the event we don't receive payment, we reserve the right not to show up for the event. Now, would I ever do this? I am not sure. If I were working with a client 30 days prior to the event and had no resolution on payment, there is a very good chance I would not show up, but it wouldn't be a surprise to anyone.

Why? Because we have that 30-day window that opens the door for conversations well in advance of the event. The last thing I want to do is wait until the week of the wedding and start looking for payment. That creates a

massive amount of tension between you and the client and, since your ultimate goal is to be a part of their big day, this is not the experience I would be looking for my clients to have.

Deposits. Deposits are nonrefundable. This needs to be stipulated in the contract. Not only does it need to be stipulated, but they better initial right next to it. All credit card companies will err on the side of the consumer if they do not initial right next to that clause. Clients can claim they never saw it or it was hard to read or understand, and the credit card companies will issue a refund 99 percent of the time. I know, because we had it happen to us. After that, we had our attorney change our contract to ensure that the initials were right next to that clause.

The rule of thumb for the credit card companies is that if the signature is more than about a thumb's width away from where it states the deposit is nonrefundable, then there is the potential for it to not have been clear to the consumer, and therefore they will refund them. The best bet is to have your contract adjusted to include the "initial here_____" language.

Staffing. What happens if you get sick or in a car accident? We have it in our contract that in the event of an emergency we'll supply a competent photographer of equal or greater skill to ensure the event goes off without a hitch. This is very important to protect you. I hope nothing bad happens to you before an event, but what would you do if you fell and broke your shooting arm? You would need to be able to have someone else cover the event for you and your studio and ensure you can still earn the income from that event. If not, the client can try to hold you in breach of contract and not pay you at all because you didn't show up. This clause will protect you. More importantly, this clause will protect the client. Why wouldn't they want someone there in the event of an emergency?

I had a father of the bride sitting in front of me once. He was an attorney. And he read that clause and said, "Uh uh, no way we're signing this!" Shocked, I said, "Really? Why not?" He said, "Well, I am not going to allow you to not show up to our event and send someone else." To which I replied, "Okay, no worries, we can cross that out, for sure. But just so I am clear, if I fall and break my arm or get in a car accident the day before your daughter's wedding, you don't want anyone from my team showing up?" He left that clause in and signed the contract.

Legal actions. How will you handle a legal action? Look, as much as I would like to think we'll never screw something up, I am a realist. Things happen. However, in the event of things happening, I don't want to be sued for every last penny I have—like our example at the beginning of the chapter. If you don't protect yourself, you too could be looking down the barrel of the $300,000 lawsuit.

In our contract, we have a clause that places a limitation on the amount of liability. I am paraphrasing, of course, but we have it stated in our contract that in the event legal action is necessary, we cannot be sued for more than you have paid us. That is huge. So, that $300,000 lawsuit would never happen. And why should it? I don't think any single image or group of images is worth paying for the entire event. You have to protect yourself from this kind of stuff. At most, I am on the hook for the contracted amount. That is still a lot of money, but it won't bankrupt my business.

Let's take it a step further. You can also have the course of action stipulated in your contract in the event of a discrepancy. Rather than going to court and incurring all those legal fees, you could stipulate that the first course of action is mediation, where you both go to a third party to play referee. This will save you a ton of legal fees and ensure you don't get caught up in the gamesmanship of the legal system. This puts you in front of an impartial third party who will hear your case and make an informed decision on the facts. Case dismissed.

Copyright. You own the copyright plain and simple! You never give that right up, even if you're giving the client a DVD of images. It should state clearly in your contract that you own the copyright and the reproduction rights of the images. Not only that, you need to stipulate how you can reproduce the images. You'll want the ability to use them in magazines, self-promotions, websites, blogs, and so forth. Don't limit yourself here. These are images you created.

It should also be stated that the client cannot reproduce these images without your approval, and that, unless specifically stated, this contract will not give them the right to use the images. You'll create a separate copyright release form, which we'll cover a little later in the chapter.

Exclusive photographer. This clause is very important. I have only had to refer to such a clause one time in my career, but it was useful to have in my back pocket. In our contract it clearly states that we're the exclusive photographer at the event and that any other photographer—paid or unpaid—who interferes with our ability to perform our duties will cause the studio to cease work until they stop interfering.

I was working a wedding once and there was a family member who was a photographer on the side; he was shooting over my shoulder the entire time. Literally shooting over my shoulder. I stepped on him twice. After the first time, I politely asked him to please give me some room so I could work. Within seconds he was on top of me again. I stepped on his foot really hard— it was an accident, of course—and then went to the groom and said "Hey man, I know this is a family member, but I have now stepped on him twice. He is completely in my way and causing me to miss shots of your event. I am going to stop shooting until you can set him straight that we're the exclusive photographer here and he has to find something else to do."

Make it clear that you own the event. We're never going to stop all the family members from taking pictures. That's not my goal. My goal is to ensure we have control of the event and my clients understand that so we avoid any "friends and family" with professional gear from trying to steal our shots.

Prices. How long are the prices in the contract valid for? Can't be forever. You need to make this clear in the contract. For us, contract prices expire 60 days after the event. This gives us wiggle room if our prices were ever to change. I don't want a client coming back to me four years after their wedding, trying to get their contracted pricing. So, we need to be clear when pricing expires.

Governing laws. It is critical that your contract covers which state's laws will govern the dispute. For example, let's say I shoot a destination client in New York, but I live in and am based in Illinois. I don't want to be sued in the state of New York. Without this clause in my contract, I can be.

If this were to happen, not only could I be sued in another state, I am 100 percent responsible for getting local representation and covering the cost of all my travel back and forth for any hearings or trial dates. Not to mention, every state has different laws. I would like to ensure the laws of my home state are in play. This holds true for all contracts listed in this chapter.

Now, of course, there are a host of other things that may or may not be in your contract. This is a great overview, but get together with an attorney and let them help you put something solid together.

Model Releases

If you're going to work with portrait clients or models, you'll need a release form of some sort.

This is key if you want to use any of your images for promotional purposes. Flyers, websites, blogs, Facebook, bridal shows, vendors, and so on—they all require you to have this release form available. We don't operate without one. For our weddings, we have this release built into our contract, but for every other facet of our business, we have clients sign off on such releases so we can showcase our work and use it to generate new business.

The model release is not an overly complicated form, but it's a very necessary one. There are forms you can purchase online; we even sell them on our website. Make the investment and ensure it's giving you the permissions you need for your business.

A word to the wise: Be diligent about getting this form signed. It's easy to just let it slip through the cracks. As photographers, paperwork is not our specialty, but I am telling you, if you neglect this form, it will come back to bite you. And do not rely on a verbal commitment from your client. It's not going to hold up in court. Be sure to get this form signed and protect yourself.

Copyright Releases

This is yet another simple form that will protect both you and your client. When you give them their DVD of images, technically they do not have the right to print from them. In fact, the print lab should ask for one as a matter of policy once they see professional-looking images. The problem nowadays, of course, is that everyone is taking professional-looking images, so I don't see anyone asking for this anymore.

Regardless, we deliver a release form with our DVDs to our clients that states what we're allowing them to do with these images. Here is an example:

> *To whom it may concern,*
>
> *The holder of this CD/DVD has a shared copyright release on their images giving them the right to print them for personal use only.*
>
> *Please contact the studio with any questions.*
>
> *Sal Cincotta*
>
> *Owner | Salvatore Cincotta Photography*
>
> *115 East First Street // Ofallon IL 62269 // 618.xxx.xxxx*

This is what we give to our clients with our logo on the letterhead. Notice we're sharing the copyright. I am not giving them full control over their images. Why? Because I want control over where these images end up. If they decide to send a bunch to an online wedding blog or some other commercial

site, I want to ensure that the right images are going up there and that my logo is part of this posting. In addition, I don't want to wake up one day and see my images in the middle of Times Square in New York City without my permission.

Limited Copyright Releases

Let's say you're doing some commercial work for an organization. You would typically not want to give them a full release on your images or your work unless that was part of the contract. The risk you run in doing that is, while you got paid a nominal fee, the image you created becomes the face of the company or their marketing for the next 20 years. Be very careful when navigating this area of your business and ensure you're thinking about the big picture.

Here are some things to consider.

Ownership of the copyright. Who will retain ownership of the copyright? This should be clear, and in my opinion, this should be you. Don't give up your copyright.

Grant of rights. This states clearly what rights you're granting to the contracted party. It is not unusual to specify where and how your images can be used (marketing, TV, web, etc.).

Rights reserved to photographer. Retain your right to license these images. Because they are your images, don't limit your ability to work with your own images.

Consideration. What is it you're getting for sharing your copyright? Is it a flat fee or a commission? You must be clear on what you're receiving and how that will be calculated and paid.

Termination. When does this agreement end? Be clear that this agreement can be terminated on a certain date. Why? Do you really want clients to be able to use your images forever? If not, grant them a 60- or 90-day use of the images. After that time, you can revisit these terms. So if they chose to use this image in ways you had not foreseen, you can now renegotiate your rate.

These are just some of the basics when putting together a limited copyright release.

Second Shooter Agreements

This is a point of contention for every single studio I know, regardless of whether you're shooting weddings or any other type of event. If you're using second shooters or contractors to assist with the job, you need to be crystal clear on what you're providing them and what they are providing you in return. In addition, it needs to be made clear who owns the images and where and how can they be used. I have been burned by this in the past, and we won't let this happen to us again.

I recommend getting in touch with an attorney to help you with this. I think every business runs a little differently, but the end goal is the same—to protect your business at all costs.

So what happened with me? Well, I had a wedding where I needed another shooter to help out. I hired a friend to assist and I paid him $250 for the day. He used his equipment and memory cards and did a pretty good job. Well, at the end of the night, I saw him handing out his personal business cards to the catering manager—unacceptable! I went nuts on him. And then a few weeks later, I saw images from my wedding on his website and marketing material. To make matters worse, he was using a key image I set up of the bride for his promotional material. It was a shot he didn't set up; instead he walked behind me and grabbed a shot of it. Now, there was no reason at the time for me to think anything of it—this was my second shooter. But in hindsight, it was clear what was happening.

Today, no shooter is allowed to use our images outside of the studio. And in order to ensure that, not only do we have a contract but we have them use our equipment when necessary, as well as our memory cards!

As far as payment goes, we typically pay our shooters $25/hour as a second shooter and $50/hour as a primary shooter. They show up, shoot, and go home. No other responsibilities. That's pretty reasonable anywhere in the country.

So what should be included in this agreement?

Event details. Location of the event, and the projected start and end times.

Scope of services. What will they be doing? An example might look like this:

The scope of services is for the Contractor to photograph and/or video the above Event. Owner may make suggestions as to how the photographs/videos will be taken; however, the Contractor is an independent contractor with the requisite experience to determine the best way and means to photograph/video the event. The Contractor shall assist and cooperate with the Owner in obtaining the desired photographs, including but not limited to specifying persons and/or scenes to be photographed. The Contractor shall not be responsible for photographs/video not taken as a result of the Owner's failure to provide reasonable assistance or cooperation.

Fees. What will they be paid and when will it be paid? If you're letting them use their own equipment or memory cards, then payment should not be made until you have received those images.

Additional expenses. Parking, rentals, and similar expenses. Who will own these costs in producing the event? It needs to be made clear in this contract. Will you cover mileage? Gas? Parking?

It doesn't have to be overly complicated. Just ensure that everything is clearly defined in the agreement so all parties are 100 percent in sync regarding what to expect.

Copyright. Who owns the copyright? This is it! This is the most important piece of this whole thing. You must retain the copyright to these images. In fact, since you'll be selling these images to the client, it's imperative that you retain these rights.

Do you really want your client to see their images on another studio's website? Or in an advertisement that has nothing to do with what it was created for?

Here is a sample of how the copyright section might read:

> *It is agreed that Owner shall own the copyright to all images created through this contract. The Owner shall have the exclusive right to make reproductions for the Owner's portfolios, samples, self-promotions, editorial use, for display within or on the outside of the photographers' studio, including the Internet. Contractor agrees to not copy or reproduce the images in any way without the Owner's express written permission. Unauthorized copying or use of these images is an infringement of Federal Copyright Law and a violation of this contract. Unless specifically stated, this contract does not provide the Contractor with any ownership of or rights to use the negatives or digital image files created under this contract.*

Next Steps ▶▶▶

While there are legal sites out there, as well as available off-the-shelf forms, I highly recommend sitting down with an attorney and be sure that they understand your needs. Most legal sites offer very generic forms. As a photographer you need something a little more specialized. Look online and see if you can find sample contracts. These serve as a great starting point for your business, but are not the final step in the process.

I can't underscore the importance of all these contracts/agreements and how they can both help and hurt your business if not done properly. Make the investment and protect yourself. Sit down and meet with an attorney, explaining your business and your concerns with each scenario. The attorney should be able to help you put a plan in place to achieve your long-term legal goals.

Finding Your Niche

THIS IS IT! You're in the home stretch and almost ready to go it alone. Now that you understand the lay of the land, it's time to start thinking about the various types of photography that exist and how you might be able to grow your business in these areas. Should you specialize or be more of a generalist?

The case can be made to go either way, but the real answer lies inside you. Your passion will bubble to the surface at some point and lead you to your own discoveries as an artist. The path isn't always clear. However, I would make the case that this entire endeavor should be a lifelong adventure for you.

In this chapter I'll offer my own experience as guidance and inspiration to finding your true calling. And remember, no matter what you do, enjoy the ride.

What Is Out There?

The good news is that if you're into photography, there's probably a niche out there for every single type of photography you can imagine. That being said, the million-dollar question is this: Can you make money at it?

I think there will always be "projects," so to speak. For me, these are things I'm passionate about, but I know there's little to no business model to be built around them. For example, I know someone whose personal project was shooting garbage all over the world. Another photographer I heard about would shoot the inside of refrigerators. These ideas may or may not be your cup of tea, but if such ventures aren't capable of sustaining your business, I qualify them as "projects" and not a business plan.

For the sake of this chapter, let's focus on potential niches that you can build a business plan around. And by no means is this an exhaustive list.

Landscape Photography

I love landscape photography. It can be merged with travel photography as well. In my line of work, I get to travel all over the world. With my travels, we have pictures from Europe and all over the United States. The combination of traveling and my love of landscapes has turned out great for our home. Everything hanging in our home is from a place we have personally visited and an image we have personally created. It's extremely exciting to have such connection to these images and to enjoy our personal artwork.

Friends and family come over and love to look at the images. Great! But can we turn that hobby into a business? Personally, I don't think so.

Today, everyone is a photographer. And the world is an increasingly shrinking place. Easy access to low-cost flights have allowed people unparalleled access to all corners of the world. Walk down the streets in New York City and every other street vendor you run into is selling pictures of major New York City landmarks. How can you compete? Really, you can't—not on a large scale anyway. Sure, a few major artists have found success in this area, but they are few and far between.

Here's my philosophy: If I can build my reputation as a high-end photographer and artist, at some point my plan is to open my own gallery where I can showcase my travel photography. I believe that once you establish yourself, selling travel photography or other various projects will become easier because you'll now have a built-in fan base.

If you're just starting out, this would not be the place to plant your flag. Even if this is your passion, you'll find this a difficult business model to get off the ground. Go out there and shoot, but just keep it on the back burner as a personal project waiting to be unveiled to the world.

Things to consider: Landscapes don't talk back. Peaceful. Slower pace. Near-impossible business model to create. Harder to create something unique.

Event Photography

This niche encompasses most events out there: sports, corporate, and dances, among others. I know several photographers who make a lot of money in these areas. I will tell you, this genre is not very artsy. These are usually high-volume events where you're pushing out a massive amount of images in a very short window of time; in some cases you might even be printing on site. It has the potential to be a lucrative business model for you.

Events happen all the time, so you'll have no shortage of work. The area is, however, very competitive. You'll need a business plan that helps you stand out from the crowd. The good news is, it can be done.

Things to consider: Every day is a new and exciting challenge. Never a dull moment. High-volume business model. It's overly saturated. Not very artistic.

Glamour/Boudoir Photography

This is a niche making a massive resurgence right now. Everyone wants to get their sexy on. Keep in mind—sexy doesn't mean naked. That's the beauty of this genre. All ages, young and old, want something that showcases them in the best possible light. The key is finding this client and establishing your niche. Be careful, though; depending on where you're located in the country or the world, this kind of work can be taboo. We used to include this option in some of our wedding packages and we had some clients who loved the idea, whereas others nearly lost their minds in a very bad way.

Also, breaking into this field could be a little tougher if you're a male. I'm not saying it's impossible; I'm just highlighting the obvious. Your client base is going to be female. A female photographer has a much better chance at connecting with the client and any concerns they may have. But there's a huge opportunity for you to establish yourself in your market. From my perspective, I wouldn't advertise this area on your main website, especially if you're also targeting kids, families, and seniors. There is sure to be a disconnect.

Finally, keep in mind that glamour/boudoir photography can be a somewhat seasonal part of your business. Christmas and Valentine's Day are going to be the biggest time of year. Of course, if you establish yourself in this niche, you should be able to get business year-round.

As of this writing, we're exploring this option for our business. We're creating an entirely separate line of business to ensure we don't scare away other more conservative clients. I see this as a huge opportunity right now.

Things to consider: Seasonal business. Potential to be frowned upon. Very popular right now. Great way to expand your core business offering. Business model should be low volume, high service.

High School Seniors

This one is near and dear to my heart. Photographing high school seniors is a great way to start working with teens. I find them to be eager to do something different. Seniors love showcasing their personalities. Getting started will take a little time, and you'll need a business plan—possibly in this area more than any other. High school seniors can be a finicky market

and demographic. These are the elusive teens. They are picky. But if they love your brand, they control the purse strings.

Along the lines of being finicky, you need to understand this is a brand-aware group. They see all the magazines and all the TV commercials. If your brand looks or feels like a mom-and-pop operation, they'll reject you. If you ensure that you're plugged into all the trends and fashions, they'll be loyal to your brand.

Targeting this market involves more than running a few ads. You'll need a "senior ambassador" program in place. You hire kids to represent your studio in the schools in return for free pictures or a similar arrangement. I've put together an entire program on this, and it will be the source of one of our next books.

We photograph 100–150 seniors per year. On average, they spend about $1500 in our studio. If you love working with kids and love creating something fashion forward, photographing high school seniors is a great option for you. Also, it's a recession-proof niche. Every year, there's a new crop of seniors looking for great images.

Things to consider: Seasonal business. Barrier to entry—need an ambassador program and advertising program. Teens are picky. Always something new. Very fashion aware. Very brand aware. Recession proof. Very profitable.

Families and Babies

Another area with great potential is photographing families and babies. Many new photographers start out in this area; you may be one of them. You wanted some pictures of your kids and family, so you picked up a new DSLR and now you're a photographer. Though there's nothing wrong with that approach, studios like ours see the most competition from the everyone-is-a-photographer crowd.

Understanding that there's a slew of competition in this area—from the box stores as well, which offer $9.99 portrait packages—approach this niche with caution. Having a solid business plan is essential. Trust me when I tell you, you don't want to shoot the budget client here. You'll be doomed to price shoppers who will reject even a $99 session fee when they can go to a

chain store and get an entire package of images for that price. You'll have to find a way to differentiate yourself from the crowd in order to command the higher session and portrait prices. The question here is, what will make you stand out from the rest? What is your X-factor?

I don't want to scare you away from this segment of the market; I just want to make sure you know what you're getting into. A lot of photographers have made a name for themselves in this part of the market. You can, too, with the right plan.

Just be sure that you love working with kids and families. For me, there's something about waiting 30 minutes for a baby to fall asleep to get that perfect shot that I don't get jazzed about. I don't have that kind of patience. I don't enjoy it; therefore, our studio doesn't offer this kind of photography. Better stated: We don't advertise this. We'll shoot families for our existing clients, but we aren't looking for new clients as part of our growth plan.

Things to consider: Extremely competitive. Year-long business model. Can be very profitable. Requires patience with your clients to get the right shot. Requires a clear level of separation to establish what makes you different.

Weddings

Lots of professional photographers shun the thought of being a "wedding photographer." For some reason, it has this perception of being at the bottom of the barrel for photographers. Not sure where that comes from, but I can tell you I absolutely love weddings! We built our business on it. Here's why I love weddings. First, from a business perspective, it allows me to forecast. In other words, I can look out to next year and tell you, here's the minimum I'll make because I have X amount in contracts. No other niche works that way. I want predictability in my business. Second, I love the excitement of the wedding day. It's a little crazy, but I like it that way. It keeps me from getting bored.

Economically speaking, photographing weddings is yet another recession-proof industry. Every year is a new crop of brides who have been waiting their whole lives for this big day, and they want their dream day documented for generations to come. That's where we come in. We offer our wedding clients a high-end experience with high-end products. This approach allows us to stand out from that weekend warrior handing out the DVD of images.

And yes, wedding photography is a competitive niche to go after, but one that's extremely easy to stand out in. Keep in mind that photographing weddings, too, is a seasonal business. Yes, you'll get the occasional winter wedding, but many people are getting married from May through October. I say that with the understanding that, depending on where you are in the country or world, you may have a different experience.

If you're looking for a low-key and low-stress industry, wedding photography is not the area for you. Things get intense during the day, and the client will need you to take control of the day to ensure things stay on track. No, that's not what the planner is for. Most weddings we shoot don't have a

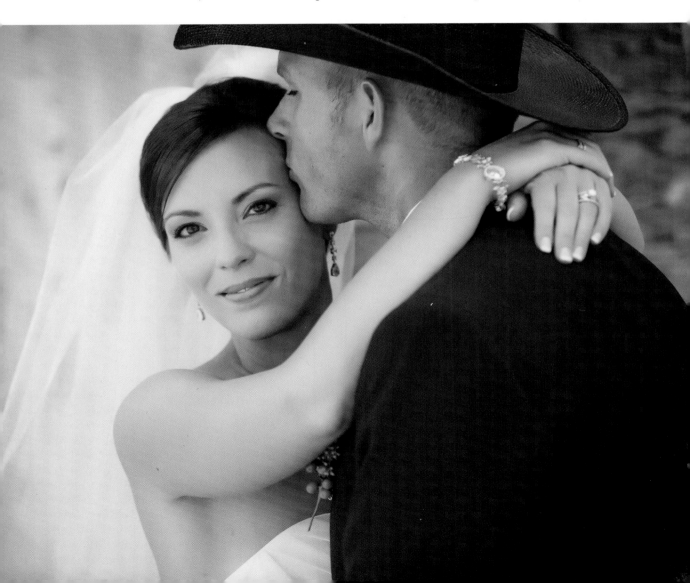

planner. And even the ones that do have a planner I find to be equally disorganized. I've worked with very few planners who are on top of things. Either way, it's on you as the photographer to ensure you get the time you need to create great images for your client. You can't blame the bride and groom when you don't have time. That's your fault.

Not only do weddings allow you to forecast your year, they are profitable. Half of our studio's business income is derived from weddings.

One of the final things to consider is this: We have developed lifelong relationships with our clients. When you book a wedding, you're typically working with these clients for a year or more leading up to their event. It's natural to become close with some of your clients. We love that aspect of this part of the business.

Things to consider: Seasonal in nature. Very competitive. Potential for controlled chaos. Lifelong relationships with clients. Very profitable. Recession proof. Must find your X-factor.

Fine Art Portraiture

Fine art portraiture is an area making a massive resurgence in our industry. As a result of all the garbage photography out there, it has become clear that there's a demand for high-end photography and products. Fine art today can be applied to any niche. To me, it's just a higher level of service offering and product offering. And with that comes a higher price point. You have to create a limited supply for this model to work. It's not a mass production business model. You're looking for elite clients looking for a specific experience.

Personally, I don't believe fine art portraiture is something you can open your door and start going after. You'll need to refine your business model and ensure you can meet the demands of these high-end clients. Our studio has developed our main brand for the last four years, and now we're pushing away from mass production and getting more into the fine art realm.

By doing fewer sessions per year, creating this model of exclusivity, and offering a product line of luxury products, we're able to start charging significantly more for our services. But if no one knows who you are, you aren't

going to be able to charge those higher prices. Why? Because they've never heard of you. You have to build a luxury brand first.

So, what goes into a fine art business? Look to the marketplace for the answer. You have to offer elite products. Your post-production has to border on artwork, not two seconds in post-production. Single-click edits or filters won't cut it here. Your products must be something not found anyplace else. We offer fine art paper and albums to our clients.

Your shooting style has to change. We shoot very big shots showcasing not only the subject but the surrounding landscape as well. It's not just about them; it's about the entire scene. Fine art doesn't come in a 4x6 for us. Fine art comes in larger wall art like 20x30 and bigger. The final product is hand delivered to the client at home, exquisitely packaged as it would be from the highest-end retailers in the world. This is an experience like no other, and it's one that clients are willing to pay a premium for.

Things to consider: This is the ultimate in our craft. You're targeting a higher-end client, one who sees the value in artwork. Price point must start higher. Must offer higher level of product or service. Can be applied to any niche. Lower volume is more susceptible to economic issues. The sweet spot here can be extremely profitable. Must offer unique value proposition.

Miscellaneous

By no means do the topics covered so far constitute an exhaustive list. A host of options exist out there—everything from magazine staff photographers to food, music, and pets. Basically, the list is endless. The question becomes: Is there a market for it? Will people pay money for those types of images?

Don't be afraid to experiment and try new things; you might be surprised. Also, keep in mind that not everything you photograph has to make money.

Whoa, mind blown alert! The business guy just told me it's okay not to make money? Yes, I did. Everyone needs a personal project to keep their sanity. I have seen some pretty crazy personal projects. But hey, to each his own. But the point is clear, get out there and find your passion.

For me, I love travel photography even though I don't make a dime at it. I find it therapeutic.

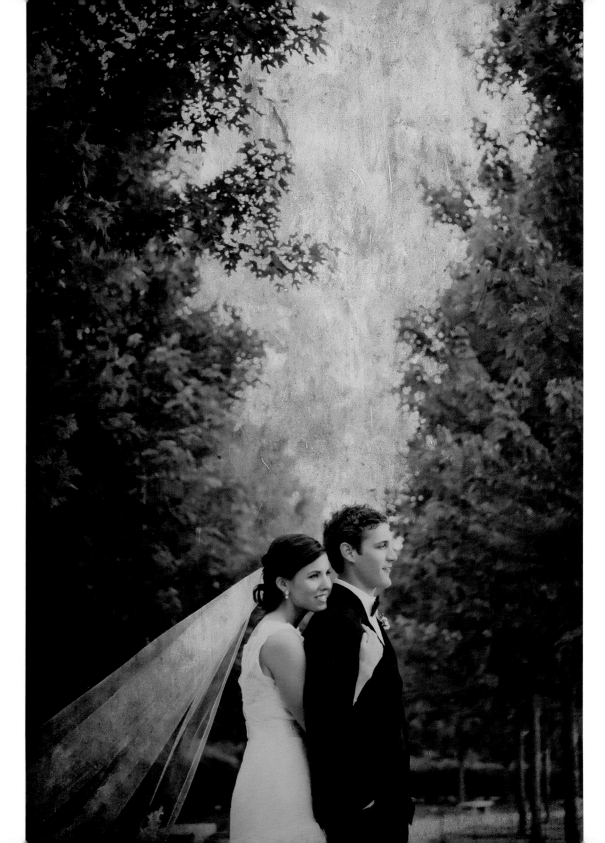

Where to Start?

Getting started is sometimes the toughest part of this whole thing. Where do you get experience, how do you get the word out, and how do you build your portfolio? All great questions. And if that weren't enough, how do you decide what niche you want to go after? These are all the challenges we faced when we were starting out. And as always, the only way I know how to teach is through my own experiences.

The biggest mistake I see newbies make is they have their camera and they're ready to go. Start shooting. Figure it out on the job. Make mistakes and learn from them. *No!* That's a horrible idea. Do you know of any other industry that works that way? You'll destroy your reputation. Sure, you're going to make mistakes, but some are avoidable and others can be absolutely disastrous to your business and your reputation.

Instead, consider an apprenticeship like every other craft out there. Learn the business from someone who is doing it every day. Work for free if you have to. Do whatever you need to do to learn the ins and outs of the business. And it's not going to be easy. Photographers are a paranoid bunch. They don't like to let others see behind the magic curtain. Maybe consider going to another market to get some training. Pay for that training. We have had plenty of people come through our studio who want to work for free in return for learning. And yes, they do the grunt work. What better way to learn? If that's not your cup of tea and you think it will take too long, then consider working with a consultant. We do weeklong consulting for new and existing studios where they come spend the week with us, and it's like a mini boot camp for them. It can jumpstart your business and help you avoid countless mistakes that will cost thousands in the end.

Yes, I do want you to get out there and start shooting. I want you to experiment day in and day out. Try new posing, new lighting, new locations. Try every niche you can. Find your style.

When I started out, I tried to be everything to everyone. Anyone who would pay money was a potential client. My, how times have changed in just a few short years. (More on that in a minute.)

Let's say you're interested in weddings. How do you land your first job? Here's how I landed mine back in 2007. I ran an ad on Craigslist. Mind you, this was back in the day when it was perfectly legit to run an ad there. The ad read something to this effect: *Local photographer looking to expand into weddings. Looking for two young attractive couples getting married in the next three months. Must send current picture. Will photograph your wedding for $500 with digital files.*

Yep, I was a shoot-and-burner—for two weddings, anyway. Within 24 hours I received over 20 emails from potential clients. I narrowed them down 100 percent superficially, of course. Hey, I wanted attractive couples. The goal was to get my feet wet and build my portfolio. The clients knew it and I knew it. This allowed me to get out there and learn a ton about weddings. We sure have come a long way since then. Today, our average wedding client spends over $10,000 with our studio.

I never put myself out there as a top photographer; everyone understood what they were getting into. Both clients were extremely happy and both ended up purchasing albums from us. From my perspective, they were both successes. We then took those images and built our own sample albums to showcase at our first bridal show, and the rest is, well, history. We are one of the top wedding studios in the area now. Are there things I'd like to have done differently? Sure, but I wanted to get into this business badly. I wanted to quit my day job. And this gave me the opportunity to do it. Two things to note: Notice how I wanted the wedding within three months and that I did this wedding for next to nothing. The goal was to build my portfolio. The sooner you get your portfolio together, the sooner you can get your marketing and advertising going.

This strategy, by the way, can work for every single niche you're targeting. Your goal in the beginning should be to build your portfolio as quickly as you can. From there, you'll have the images to put on your website, blog, flyers, and so forth. You need to show your work in order to attract clients.

The next question should revolve around finding your personal style. How do you identify what you love and are passionate about? That took me about two years to figure out. Finding what you're passionate about is very important for the overall success of your business and for your own personal creativity. The last thing you want to do is go to work every day doing something you hate.

Generalist or Specialist?

Should you be a specialist or a generalist? That's a question only you can answer, but I strongly lean toward specialization. Like I said, it took me nearly two years to figure that out. In the beginning, I was trying to be everything to everyone. Anything or anyone who would step in front of my camera I would gladly photograph. And the truth is, I hated most of it but didn't know any better. I just assumed that's the way it was.

Babies were the worst for me. It was not my thing. There has to be something you just don't love. My advice: Stay away from it! I had no one guiding me at all. I had to figure this all out on my own. I wish I'd someone to guide me or had a book like this. Back then, this was all taboo. No one would talk about the business side of things, and if they did, it was always cryptic. If you do what you're passionate about, you'll never work a day in your life.

Let's explore both business models: generalist and specialist.

As a generalist, you'll be able to photograph everything. So, if one niche slows down, you can invest your time in a part of the business that's really picking up. However, as a generalist, you'll have a difficult time establishing yourself as an expert in any given discipline. With that expertise comes a bigger payday. Think about this in the real world. Experts or specialists always make more money than a general practitioner. Plus, how do you ever get to do what you love doing? Most people don't love *everything*. There has got to be one or two things you're just giddy about. That's where you should spend your time—become a specialist and focus on that niche.

As a specialist, you'll become the expert in that field, and as the years go on, your portfolio will reflect that. You'll showcase your talent in a focused way, sending the message to your clients that you know this field. Everything you do should be focused on becoming an expert. You need to understand trends in the market, and in some cases, try to set the trend yourself. You become fashion forward and your clients will be willing to pay more money for that level of service and vision.

I just want to reiterate: This is where I made some of my biggest mistakes when I was starting out. I'll be the first to tell you that the only way to know what you want to do is to try a bit of everything, but you have to figure that out as soon as you can. This strategy will allow you to develop a business

model toward your client base and get laser focused. My recommendation is for you to spend the first 6–12 months shooting everything you can. Every day has to be a learning experience for you. I think this holds true even if you're an established studio looking to branch out into a new niche. Get out there and experiment.

Once you know what you love, a business plan has to be the very next thing you tackle. How are you going to grow this part of your business? This plan is paramount to your success. You can't just say, "Yay, I'm a wedding photographer now!" It doesn't work that way. You need solid business principles in place. You need a portfolio to show perspective clients.

Style

The final topic I want to discuss is style. Let's say you take my advice and go through this whole process and you end up being a high school senior photographer. Within that framework, you'll still need to define your style. It truly is a two-step process. One step is figuring out what you love. The next step is determining what your style will be. Will you be a traditional photographer—shooting in the studio or on white backgrounds—or will you be a natural light photographer shooting on location? Or are you one of those photographers who loves to bring out the flashes and lights on location?

The big challenge here is to understand that how you shoot will ultimately impact your brand and the type of clients you attract. For seniors, we don't shoot in the studio. Everything we do is on location. We don't attract those clients who are looking for studio sessions. Our clients are passionate about our style; they're looking for on-location urban architecture. If you don't define your style, you run the risk of trying to be everything to everyone in the niche. Doing so leads to disappointment among your clients. They're frustrated because they come to you for a certain type of session and then you don't meet their expectations because you're all over the map with your style. You have to be consistent!

Every client who walks into our studio or visits our website sees a clear and consistent style. Love it or hate it, they know what they're getting. We attract the right kind of client, one who appreciates our artwork and our vision. If you're going to be successful in this industry, finding the right clients has to be your number one goal.

Next Steps ▶▶▶

So, where do you go from here? The future is yours! Your best bet is to get out there and just start shooting. And for the record, I don't care if you are a 15-year veteran in this industry or you've just grabbed a camera for the first time. Try a bit of everything to get a sense of what you love and then go after it full force using the tools and techniques you learned in this book.

I'm like any other photographer; I get burned out and I'm always looking for new ideas and inspiration. Well, recently, we started playing around with the idea of adding glamour photography to our studio. What did I do? Scheduled a few shoots with past clients to see if it's something we want to get into. And though I'm not sure if it's something we'll add to our studio, the point is that we're always exploring new options.

You constantly have to try to reinvent yourself to ensure you stay relevant. Good luck on your journey, and I hope this book has helped you define—or redefine—your own path.

Index